IMAGES
of America

THE LONG BEACH
PENINSULA

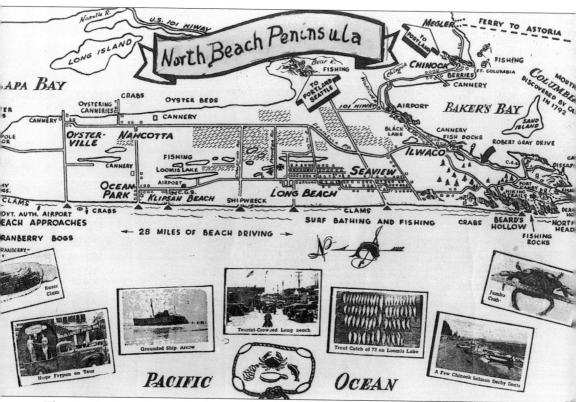

The North Beach Peninsula (Long Beach Peninsula) is surrounded by the Pacific Ocean, Willapa (Shoalwater) Bay, and the Columbia River. It is well known as a tourist destination and for its natural resources. Clams, oysters, fish, and cranberries are sought after both commercially and for sport. The beaches of the Peninsula have been the resting place for many shipwrecks due to the proximity to the Columbia River bar. Because of this, the area is also known as the "Graveyard of the Pacific."

IMAGES
of America

THE LONG BEACH PENINSULA

Nancy L. Hobbs and Donella J. Lucero

ARCADIA
PUBLISHING

Published by Arcadia Publishing
Charleston, South Carolina

Printed in the United States of America

Library of Congress Catalog Card Number: 2005925444

For all general information contact Arcadia Publishing at:
Telephone 843-853-2070
Fax 843-853-0044
E-mail sales@arcadiapublishing.com
For customer service and orders:
Toll-Free 1-888-313-2665

Visit us on the Internet at www.arcadiapublishing.com

CONTENTS

ACKNOWLEDGMENTS

We would very much like to thank our family and those who so generously shared their photographs with us. Thanks to our father, Don Urban, who, along with our grandparents, loved to take pictures of the Peninsula, and to Donna Alexander for sharing some of the Peninsula's photographic history with us. We give thanks to Dick and Martha Murfin for providing us access to many *Ilwaco Tribune* photographs, and a special thanks to Sylvia Gensman, who came to the Peninsula as a young girl and shared with us some wonderful photographs, experiences, and history of the beach.

We acknowledge the University of Washington archives and Washington State Parks and Recreation Commission for providing us with photographs that also help tell the story of the area.

Without the assistance of those we most graciously acknowledge, we would not have been able to complete this photographic history book. Thank you!

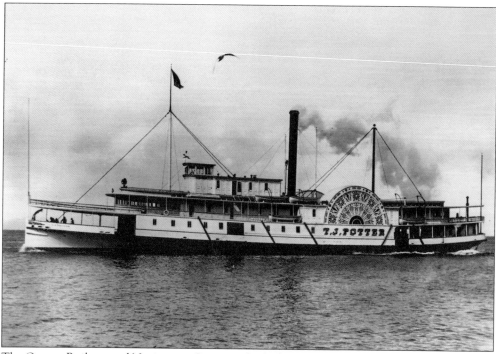

The Oregon Railway and Navigation Company built the *T. J. Potter* in 1888. It was 230 feet long and 35 feet wide. In 1901, after the boat was remodeled, the *Potter* could make the trip between Portland and the Peninsula in approximately six hours. At that time, the passenger fare was $2.50. If you wanted a stateroom, it was an extra $1.25. Meals in the luxurious dining room were 50¢.

INTRODUCTION

The Long Beach Peninsula is located in the southwest corner of the state of Washington. It is almost surrounded by water, with the Columbia River on the south, Willapa Bay on the east, and the Pacific Ocean on the west. Only a narrow band of land connects it with the rest of the state. The Peninsula boasts a continuous 28-mile driving beach and is itself about 32 miles long and 2.5 miles wide. This area is known for its fishing, clamming, oysters, cranberries, and is also a major tourist destination.

The Peninsula was the land of the Chinook tribe, the end of the trail for Lewis and Clark, and a site full of history for those who seek it out. Several communities are located on the Peninsula: Chinook, Ilwaco, Seaview, Long Beach, Ocean Park, Nahcotta, and Oysterville.

The site of a major river, thought to be the "River of the West" and the entrance to the Northwest Passage, was noted on maps by several early explorers and traders. Not until American explorer Robert Gray documented his entry into the channel in 1788 was it determined that there was actually a river there. Named for Gray's ship, the *Columbia Rediviva*, the Columbia River was eventually documented on maps, used by later traders and explorers, and became a waterway bringing European settlement to the land accessed by the river.

In November of 1805, Lewis and Clark followed the Columbia River to its mouth, where it meets the Pacific Ocean. On the Long Beach Peninsula, they completed their charge by Pres. Thomas Jefferson to reach the ocean. After arriving, they noted signs that fur traders had already influenced the area and hoped to make contact with them, but were not able to do so. By the time Lewis and Clark returned to the east, the push west had already begun.

As outside settlers came in to the Peninsula, they took over Chinook lands and formed communities mainly around the fishing and oyster industries. These natural resource–based businesses created an economic boom and brought even more settlement to the area.

This book documents, through pictures and photographs, some of the communities, industries, the military, maritime facets, and other draws to the area from the 1880s to the early 1950s. The purpose of this book is to show some of the more interesting history of the area and what features drew people to this remote land between the ocean and the bay.

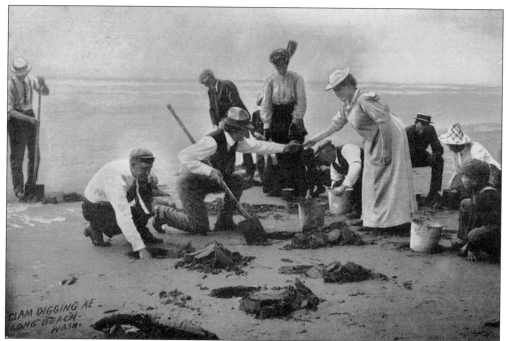

Clam digging on the beach was one of many pastimes both visitors and locals enjoyed. In the past, visiting the beach with friends could be quite a social event. In this photograph, the ladies and gentlemen are rather well dressed for such a wet and messy venture.

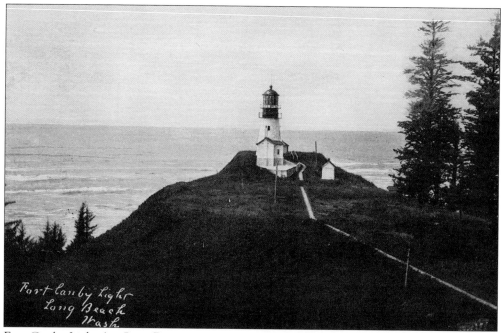

Fort Canby Light (or Cape Disappointment Light) has stood as a sentinel at the mouth of the Columbia River since 1856. It is one of two lighthouses at the south end of the Long Beach Peninsula.

8

One
PENINSULA COMMUNITIES

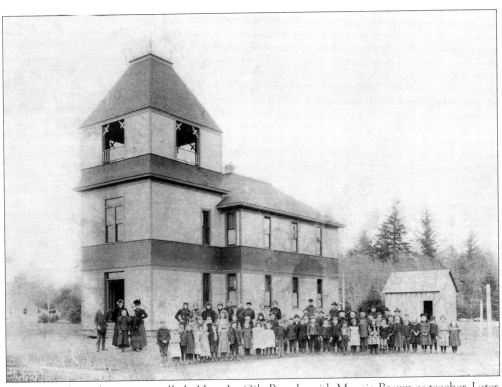

School at Chinook was originally held at the Gile Ranch, with Maggie Brown as teacher. Later, the school was moved to the Jasper Prest Ranch. In 1897, a new two-story structure was built. Many students attended school here until a one-story replacement was built in 1923.

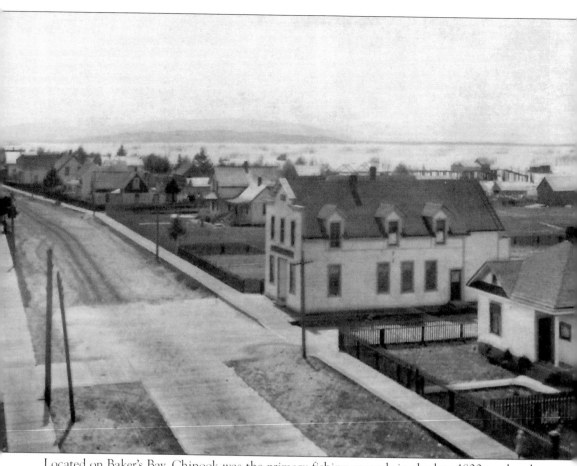

Located on Baker's Bay, Chinook was the primary fishing grounds in the late 1800s and early 1900s. It was well known throughout the country for its salmon fishing and was at one time the richest town per capita on the West Coast, which included a post office, saloon, general store, two churches, and many fine homes. From 1900 to 1905, the town had a population of about 700 people. Chinook also grew with the increase of troops at Fort Columbia during the Spanish-American War, World War I, and World War II. This photograph shows the main road going through Chinook. After 1891, when the bridge was completed across the Chinook River, the road from Chinook was extended to Ilwaco. Until then, transportation was by boat. The large building on the right side of the road is the original *Chinook Observer* newspaper office.

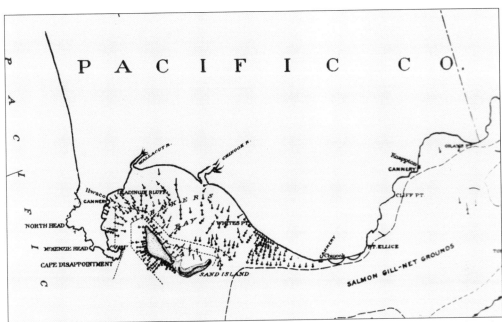

This map shows the number of fish traps in the Columbia River and Baker's Bay. After the introduction of fish traps near Chinook, the town blossomed. Many businesses flourished, and many large homes were built during this period.

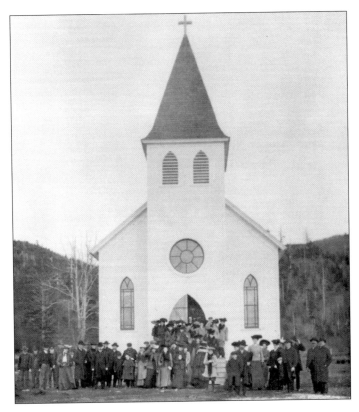

St. Mary's Catholic Church at McGowan is located on the old Stella Maris, "Star of the Sea," mission grant given to Father Lionnet. P. J. McGowan purchased a large portion of this land grant for $1,200 and built his home and cannery on this site. During the summer months, St. Mary's Catholic Church still conducts services. (Courtesy of *Ilwaco Tribune*.)

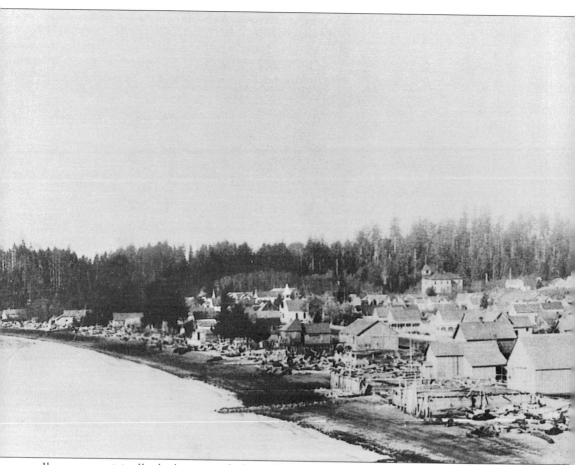

Ilwaco was originally the location of a large Chinook village. When it was visited by Lewis and Clark in 1805, there were few Chinook left in the area. Capt. James Johnson, a Columbia River bar pilot, took up the first donation land claim at Ilwaco in 1848 and built a home where he lived with his wife and children. Johnson drowned while crossing the river and left behind a legend of hidden money and gold. For many years, people have hunted for this treasure on the hill at Ilwaco. In 1859, Isaac Whealdon purchased Johnson's land and house after he and his family were forced to leave Pacific City. The history of Ilwaco is tied with that of the town of Pacific City, just to the west. The city was an ambition of Elijah White, who hoped to create a town and a fortune. Pacific City's demise came about when the federal government took over the land for a military reservation named Fort Canby. Ilwaco grew as people attracted by the fishing industry came into the area, and more homes began to be built.

Union soldiers stationed at Fort Canby, along Baker's Bay near the Columbia River, first named the town "Unity." A few years later, the name was changed to Ilwaco, which became a popular fishing port when fish traps came into use. Many canneries and businesses were built in Ilwaco in support of the fishing industry. After World War II, sport fishing became more popular and Ilwaco was considered the "Fishing Capital of the World." (Courtesy of MSCUA, University of Washington Libraries.)

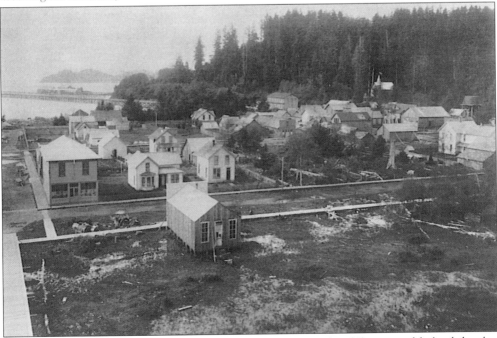

J. D. Holman received a donation land claim on the west side of Ilwaco and helped develop the town into a destination for settlers and tourists. Mr. Holman platted the town in 1872 and continued to promote the site as a great place to live and work. (Courtesy of MSCUA, University of Washington Libraries.)

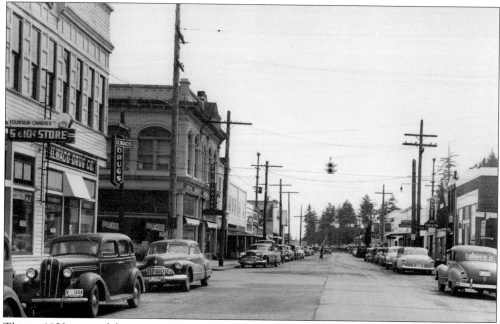

This c. 1950 view of downtown Ilwaco shows Main Street and the business district. The large dark building on the left was formerly that of B. A. Seaborg's Aberdeen Packing Company. It later became Doupe's Store (pictured).

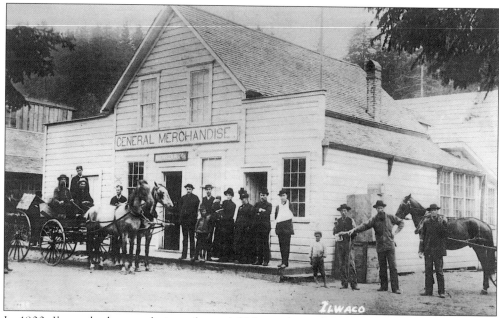

In 1900, Ilwaco had a population of over 1,000 people, and most of the businesses in town supported the booming fishing industry. Ilwaco also had two grocery stores, two hotels, two restaurants, three churches, three saloons, a newspaper (the *Pacific Journal*), and even an opera house. This photograph of the Ilwaco General Merchandise Store shows one of the two general stores in town at the time.

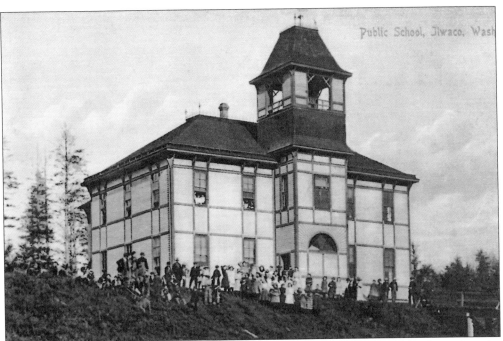

In 1914, the Ilwaco School was perched on the hillside overlooking the Columbia River. In order to go to school, students had to cross a wooden trestle bridge. The bell in the tower could be heard all over town calling students to class. The school was also a place where many community activities and events occurred.

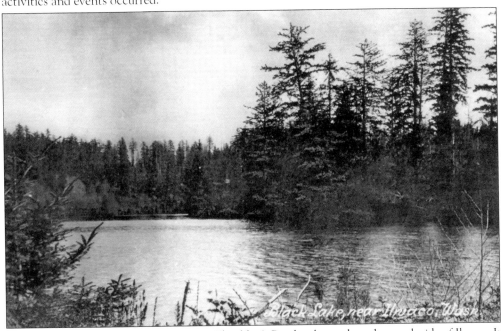

Black Lake, also called Johnson Lake or Whealdon's Pond, is located on the north side of Ilwaco. It has always been a popular place to fish and boat, and at one time B. A. Seaborg had his sawmill on the north end. The mill cut the boards used to make boxes for canned salmon. On the south side of Black Lake ran the railroad tracks coming from Megler to the Peninsula. (Courtesy of Donna Alexander.)

Sprouting up from the rocks just south of Seaview were many rustic summer cottages. These houses were not far from the water, and occasionally during winter storms were damaged by incoming waves.

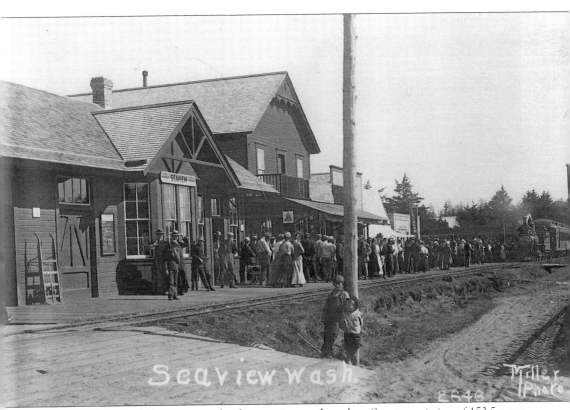

The original town of Seaview was a land grant given to Jonathan Stout consisting of 153.5 acres just south of the town of Long Beach. Stout and his wife, Annie, platted the town in 1881, but began selling parcels of land as early as 1874. Several years later, in 1886, Stout built the Seaview House, a large hotel and a store. He hoped to attract many people to his resort. The next year, he and Annie divorced, and she received a large portion of the land. When Stout died, his daughter Inez inherited what was left of his land. She and her husband, Charles Beaver, built the Shelburne Hotel, and Frank Strauhal bought Stout's store. Frank Strauhal offered to donate a parcel of property to the railroad company for a depot if they would run the train tracks through Seaview. The depot, pictured here, is located on that site in the middle of town, close to hotels and shops. (Courtesy of MSCUA, University of Washington Libraries.)

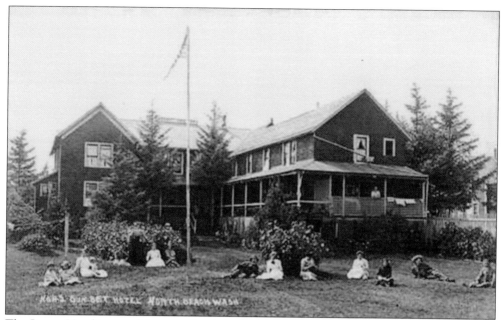

The Sunset Hotel is one of the many hotels built in Seaview and very typical of hotels constructed during that time. With the central location of the train depot and shops and the proximity of the beach and ocean, many people were anxious to get off the train at Seaview.

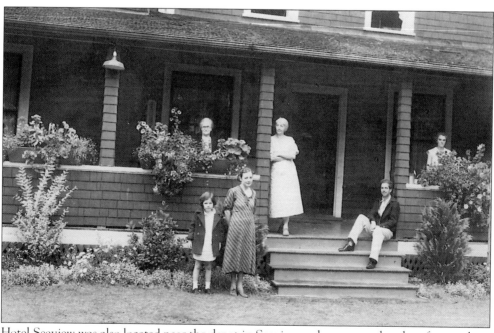

Hotel Seaview was also located near the depot in Seaview and was a popular place for people to stay while at the beach. It was owned and operated by E. A. Gensman and his wife. Pictured are Mrs. Gensman (top left on porch) and her future daughter-in-law Sylvia Gensman (second from left on lawn). (Courtesy of Sylvia Gensman.)

Mrs. Gensman's business card for the hotel invites guests to "make our house your home by the sea." The Hotel Seaview was a fashionable place for visitors to stay while on the Peninsula. The card notes that the hotel was open year-round with private baths, hot and cold water, garages, and excellent meals.

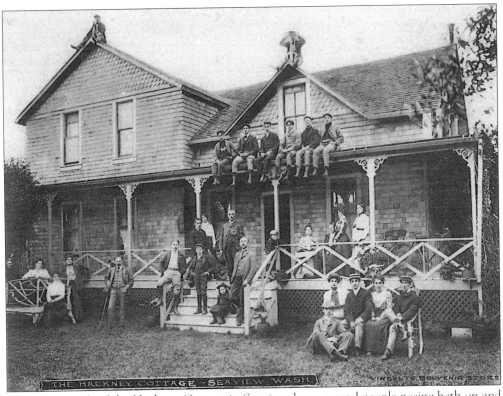

This photograph of the Hackney Cottage in Seaview shows several people posing both on and in front of the popular hotel. Along with Sunset Hotel, Hotel Seaview, and the Shelburne, this was one of the many places to stay in Seaview.

19

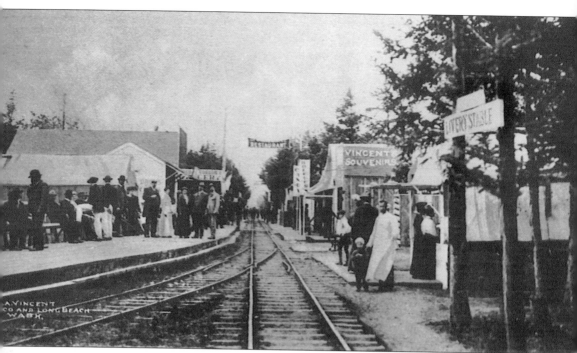

Henry Harrison Tinker purchased a land claim from Charles E. Reed in 1880 and brought his wife, Nancy, and children Lena, Gilbert, and Harry with him. At that time, Long Beach was mostly wilderness, but over a period of many years land was cleared and buildings were constructed. Tinker had a dream of a vital community at the beach, platted his town, and named it Tinkerville. Tinker's dream was also that Long Beach would become a significant tourist destination. A group from Portland purchased property from Tinker and formed the East Portland Camp. Eventually rustic businesses and houses lined its streets. A railway was also built through the middle of town, offering transportation for tourists and locals alike.

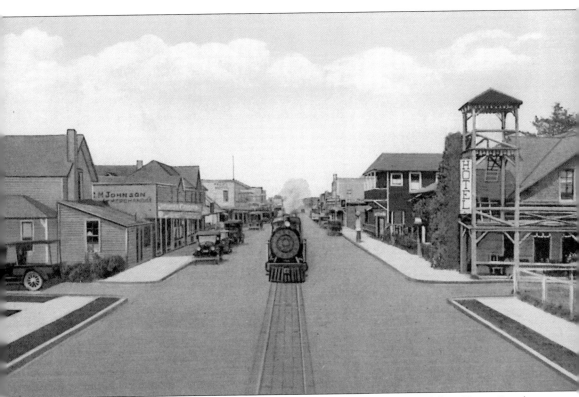

The Ilwaco Railroad and Navigation Company train ran through the middle of Long Beach. It provided daily transportation to all the towns on the Peninsula from Chinook to Nahcotta. This picture of Long Beach's north end is a stylized version of what the main street looked like in the early 1900s. The tower of the Driftwood Hotel is on the right and Johnson's Mercantile is to the left of the train. There were several fine hotels, a natatorium, a bowling alley, salt and fresh water baths, curio shops, a dance hall, a movie house, and many other attractions for both residents and tourists.

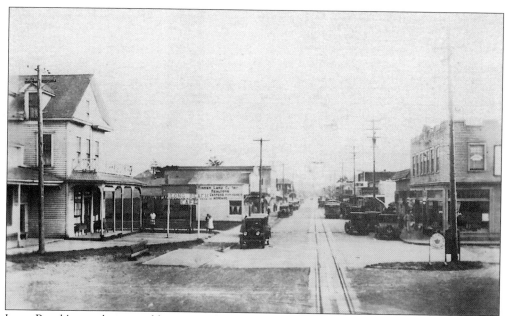

Long Beach's population and businesses have grown over the years. This photograph shows the main street, looking south. The two-story Long Beach Hotel is on the left, next to the Tinker Land Company. On the right is a "Red and White Store," which later became Ted's Grocery.

The main beach approach in Long Beach offered a way for locals and tourists to get close to the ocean. By walking or driving down the approach, 28 miles of driving beach were accessible to those wanting a close-up look at the Pacific Ocean. Activities for beach visitors included beachcombing, picnicking, fishing, clamming, and surf bathing.

Long Beach Boulevard ran parallel to the ocean. During high tide, waves would often carry driftwood and sand over the street, and at times water would even run into the main street of town. Over the years, sand accumulated and a small ridge was created so waves would no longer reach the boulevard. This area now contains many homes and businesses.

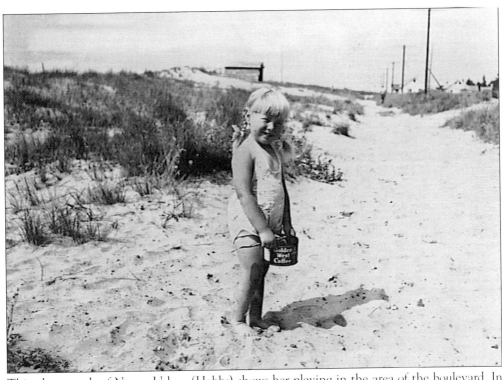

This photograph of Nancy Urban (Hobbs) shows her playing in the area of the boulevard. In 1947, the street was soft sand at the south end of Long Beach. It was seldom traveled by vehicle as people became stuck in the sand. At that time, it was an excellent place for a child to play.

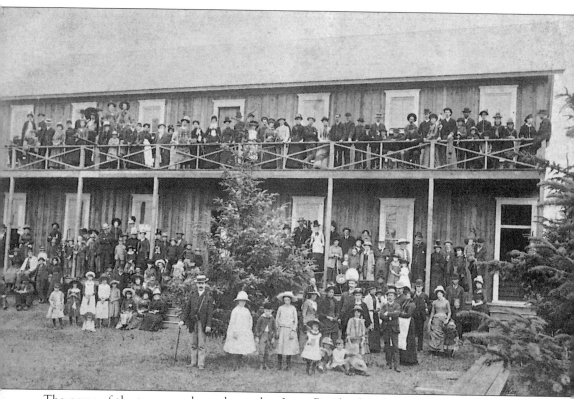

The name of the town was later changed to Long Beach after the 28-mile-long beach of the Peninsula. Henry Tinker and his family built the first Long Beach Hotel in a location Tinker designated as the middle of town. A popular place for tourists to stay while visiting, it was a main stopping point for the horse-drawn stage that transported visitors along the Peninsula. The hotel also contained a dining room that served many fine meals before it burned down in 1894. Even after this, Henry Tinker continued to promote and work on his beloved town. His hard work paid off, and Long Beach became a vital business and resort area on the Peninsula.

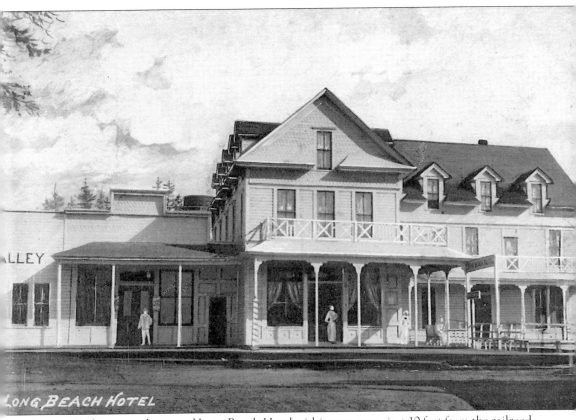

Henry Tinker erected a second Long Beach Hotel within two years, just 10 feet from the railroad tracks. It was said to be so close that on rainy days a long plank was set down between the hotel steps and the train to allow passengers to exit without getting their feet wet. Several years later when Tinker's son Gilbert was mayor, the hotel and other businesses were moved away from the tracks. This allowed room for automobiles to travel in town. The Long Beach Hotel was a popular gathering place located just south and east of the train depot. In this particular photograph, other shops on the north side of the hotel are visible, including a bowling alley and a shop that sold a variety of items and also rented clam shovels for visitors to use in their hunt for the plentiful razor clams along the beach. The hotel also had an excellent dining room and, in later years, a saloon.

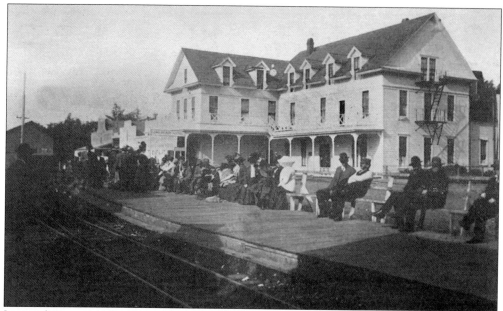

Lining the streets in front of the Long Beach Hotel, near the railroad tracks, were many benches. This area was called "Rubberneck Row." Here people would gather and watch the comings and goings of the town. It was a nice place near the stores to talk with friends or wait for a relative to arrive on the train.

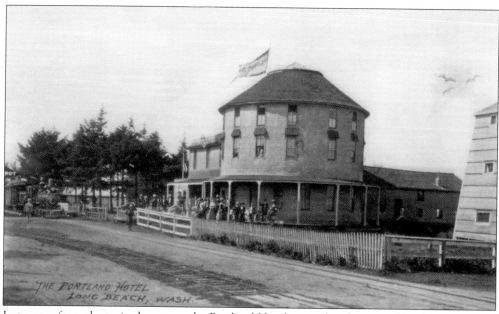

Just across from the train depot was the Portland Hotel, owned and operated by the Hanniman family. The hotel was unique due to the large round look of the building's front. At the top flew a flag that said "Portland Hotel." Along with the hotel, the building held a saloon and popular dining room. On December 6, 1914, it was destroyed by fire and never rebuilt.

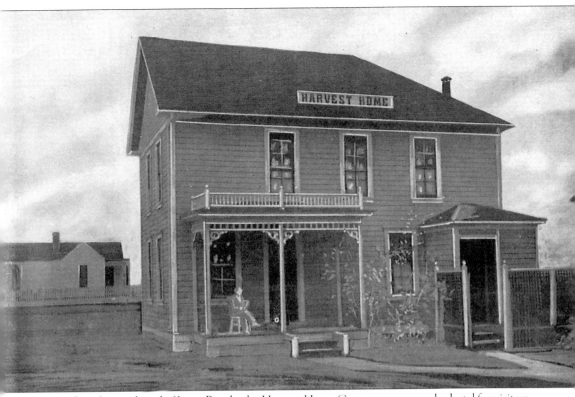

Located on the south end of Long Beach, the Harvest Home Cottage was a popular hotel for visitors. Because both the beach and town were in very close proximity to the Harvest Home Cottage, it was a convenient place to stay. It was named after a shipwreck that was also a popular tourist destination. The Harvest Home, along with other hotels such as the Pacific Hotel, Chamberlin's, Ocean View, North Beach Inn, and Shagren's Hotel, provided a clean place to stay and a warm meal. In 1923, the Shagren Hotel advertised an excellent view of the ocean and dinner for $1. The meal included clear consommé, salmon pattie, combination salad, spring chicken, new potatoes and peas, sauté corn, fruit Jell-O with whipped cream, and a choice of beverage. (Courtesy of Donna Alexander.)

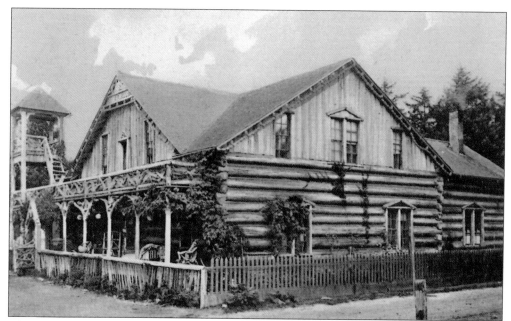

The Driftwood Hotel, located in downtown Long Beach was built by Mr. Merritt in the 1880s out of logs and driftwood he found on the beach. The hotel was later purchased by Tom and Mollie Lyniff, who continued adding driftwood and parts of shipwrecks to the structure. Along with the hotel, the Driftwood had a saltwater bathhouse. In 1910, visitors could enjoy a room and visit the bathhouse for $2 a day.

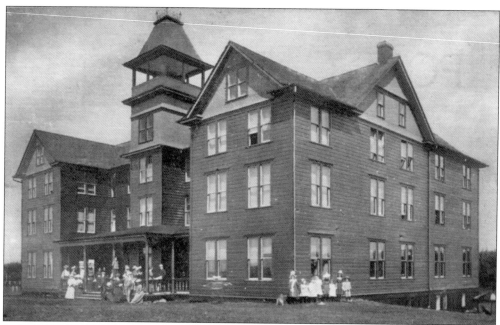

In 1901, the Breakers Hotel, one of the largest and fanciest places to stay, was located just north of the town of Long Beach. It overlooked the ocean and hosted beach visitors until it burned down in 1904. Owner and operator Joseph M. Arthur decided to rebuild his hotel even bigger and better.

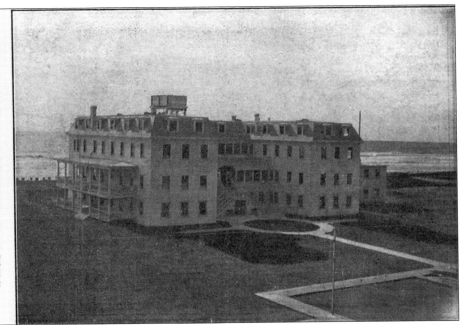

The new Breakers Hotel was made much larger than the first. It was 70 feet by 100 feet and had 126 guest rooms. Joseph Arthur advertised hot and cold fresh and salt water, tennis courts, and a bowling alley. He claimed to have the "Best Ladies Orchestra and a Large Dancing Pavilion." Rooms ranged from $12 to $18 a week.

This advertising card shows potential visitors that the Breakers was the "Social Center of the Summer Season." Arthur also advertised the hotel as the "Leading Coast Resort of the Pacific Northwest." The second Breakers was one of the largest hotels on the Peninsula at the time and had many activities available to its guests.

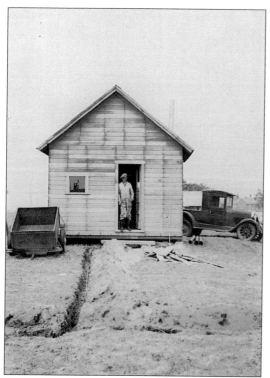

Hundreds of tiny cottages were built like the one in this photograph. During this period, cottages were built without the use of electrical equipment—each board was hand cut and each nail hammered. Cottages were rented to tourists by the day, week, or month. Many were built near the beach so the ocean could be viewed from their windows.

Looking north on the boulevard, this photograph shows Urban's Court. Many courts boasted cottages built to accommodate two to eight people. Some were built with kitchens for those who wanted to do their own cooking. Many courts, just like this one, sprang up throughout the Peninsula to house the hundreds of tourists that visited the area, and many became repeat customers.

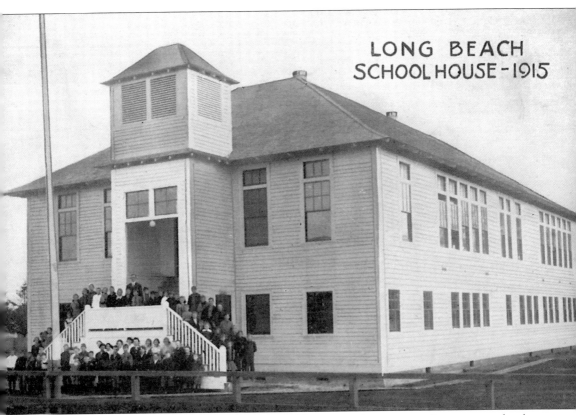

LONG BEACH SCHOOL HOUSE - 1915

Many of the early classes on the Peninsula were held in private homes or small one-room schools. As the area's population grew, larger schools were needed. The first school in Pacific County was the Oysterville School on the north end of the Peninsula, a one-room schoolhouse built in 1863. By 1874, a larger two-story school was needed to accommodate the growing number of students. It burned down in 1905 and was replaced in 1907. The Long Beach School building, pictured here, had several classrooms on the top floor with another classroom, a lunchroom, and a furnace room below. The two-story elementary school was located on Washington Street in Long Beach and was eventually torn down and replaced by a more modern school. A separate gymnasium building was located next to the school.

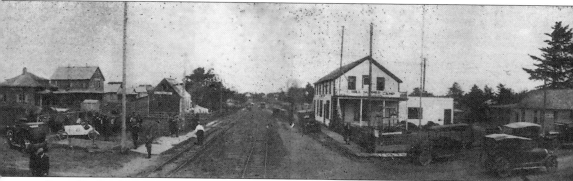

Part of Hill Military Academy of Portland, Hills summer Camp owned and operated by Joseph and Benjamin Hill for boys ages 6 to 18. Campers would study their schoolwork and also enjoy playing, swimming, and picnicking from July 1 through September 1. The camp a dormitory for staff and students, an administrative and dining hall, and a clubhouse. The main administrative building (the white two-story building) was formerly the old Black's Hotel. The dormitory had a house mother and several assistants who kept tabs on the students. According to an advertisement, staff regulated and managed "every detail of camp life. A little constructive work and considerable play, good meals, regular hours for sleep and exercise, much fresh air, careful discipline, and influences for refinement and wholesome enjoyment round out the camp life at Hill summer camp." The summer camp closed around 1925 because of lack of enrollment.

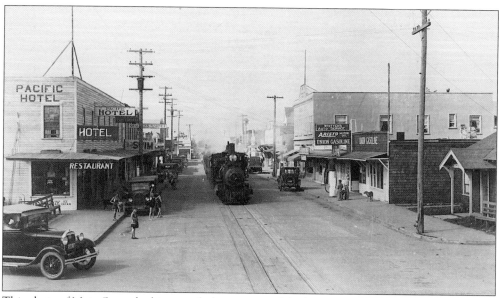

This photo of Main Street looking north shows many of the businesses in town between the 1920s and 1930s. The small building at the far right was the police station and jail.

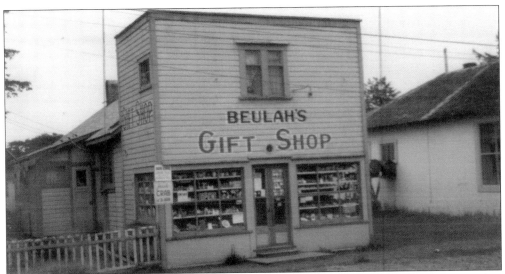

Beulah's Gift Shop in Ocean Park was one of the many shops on the Peninsula that catered to tourists and offered souvenirs, gifts, crabs, clams, and any necessities that visitors to the area might need or want. Many gift shops had a small photo studio in the back where they took photographs of people that were made into postcards.

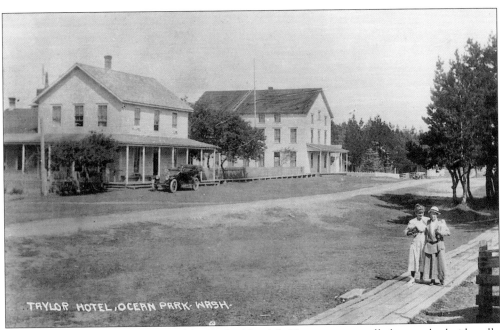

This photograph provides a view of the Taylor Hotel (left) as women stroll along a plank sidewalk, walking toward the Ocean Park approach to the ocean. A sidewalk and dirt road ran all the way east to Nahcotta on Shoalwater (Willapa) Bay. Ocean Park was first developed as a Methodist Camp where there would be no saloons and no undesirables. Those who wanted a quieter life moved to Ocean Park.

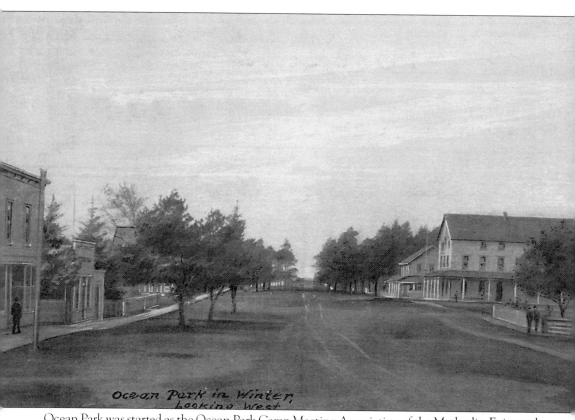

Ocean Park in Winter,
Looking West

Ocean Park was started as the Ocean Park Camp Meeting Association of the Methodist Episcopal Church as a site for camp meetings and as a resort for this group. The association platted the 250 acres into plots of 50 by 100 feet that were leased only to members. In 1888, the camp association began to sell lots to anyone on the condition that the buyers not use or manufacture alcohol or gamble there. Since that time, the town has grown. A dirt road and plank walkway connecting Ocean Park with Nahcotta on the bay allowed people to travel between the ocean and the bay in easy fashion. This view of Ocean Park was captured from the east side of town with the ocean in the distance. In the early 1900s, the water was very close to town. Over time it has receded and some beach land has accumulated. Several businesses line the streets, providing many places to shop for locals and visitors to the area.

In 1906, Ocean Park offered a wide variety of shops and activities for the tourist. This street view shows the I. A. Jones home, Mrs. Hadley's Bake Shop, and the Ocean Park Chapel. Tourists enjoyed strolling and shopping in the various stores and businesses. When the train made transportation to the north end of the Peninsula easier, it attracted many people who supported the businesses in town.

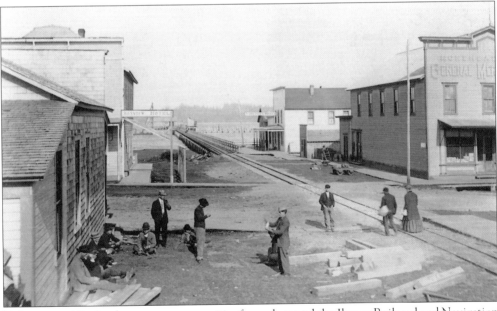

Nahcotta and Sealand were two communities formed around the Ilwaco Railroad and Navigation Company rail line. Sealand is located on the left side (north) of the tracks and Nahcotta is on the right (south). There was much competition between the two towns. The post office and newspaper were located in Sealand, while the general store and railroad facilities called Nahcotta home. This competition continued until 1893, when the post office was transferred to Nahcotta and the area has been known by that name since. The small town thrived until a fire in 1915 burned down most of the buildings. Nahcotta never recovered as a town but today is the center of the oyster industry on the Peninsula. (Courtesy of MSCUA, University of Washington Libraries.)

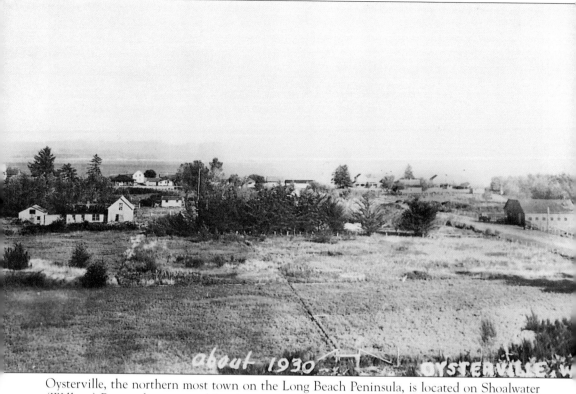

about 1930 OYSTERVILLE, W

Oysterville, the northern most town on the Long Beach Peninsula, is located on Shoalwater (Willapa) Bay, and was named for the oysters that were so plentiful. The land was once the winter home of the Chinook Indians, who called the area *tsako-te-hahsh-eetl*, or "place of the red-topped grass." The town was founded by Robert Hamilton Espy and Isaac A. Clark. In 1854, Espy began to buy up oyster grounds on the bay while Clark took out a donation land claim and platted the town of Oysterville. Because of the oyster industry, it became a popular place to live and work, as well as a tourist destination. During the height of oyster harvesting, boats from San Francisco would dock, wait for a shipment of oysters to be harvested, and then return with their cargo. In 1865, a special election was held to vote on the location of the Pacific County seat. In that election, Oysterville was selected as the center of government for the county. With this election, the town became even busier. Both the population and number of businesses grew as people came to Oysterville to attend the courts and do their county business.

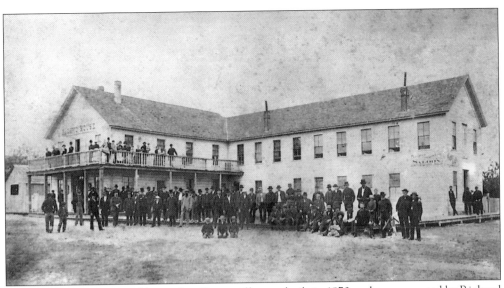

The Pacific House, a hotel located in Oysterville, was built in 1870 and was operated by Richard Carruthers. With many tourists, businessmen, and people waiting for their day in court, this hotel served as a popular resting place. When the Pacific County courthouse was forcefully moved to South Bend, the need for people to visit the town dwindled, as did the business of Pacific House.

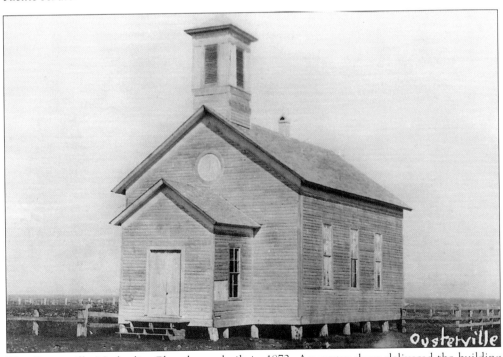

The Oysterville Methodist Church was built in 1872. An oyster sloop delivered the building supplies, which were donated and came from South Bend. A small 28- by 40-foot building at first, the tower to house the bell, donated by the Crellin family, and the front extension were both added at a later date. The church stood until January 29, 1921, when it was blown down by high winds.

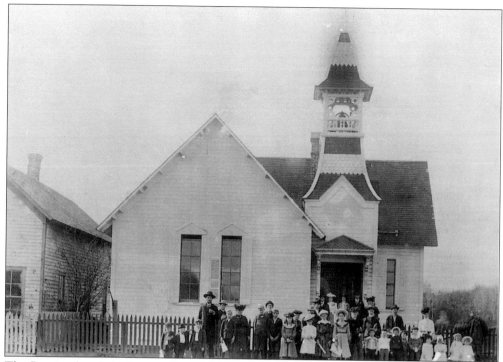

The Baptist church in Oysterville was built in 1892 and donated to the community by R. H. Espy. After the Oysterville Methodist Church blew down, it was the only church left in town. It still stands, has been restored, and is currently used by the community for many special events. (Courtesy of the *Ilwaco Tribune*.)

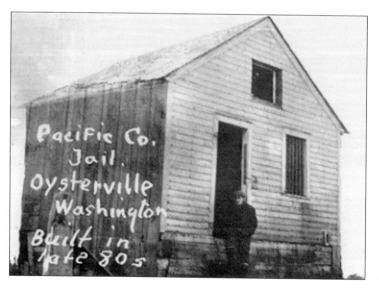

Pacific Co. Jail. Oysterville Washington Built in late '80s

The Pacific County Jail in Oysterville was constructed about 1869 [not in the "late '80s"] at the same time as the county courthouse, as a separate building but on the same site. Inside the jail were a wooden stove, kitchen utensils for the prisoners to use, and a steel cell. Later converted to a barn and used for storage, the building eventually collapsed.

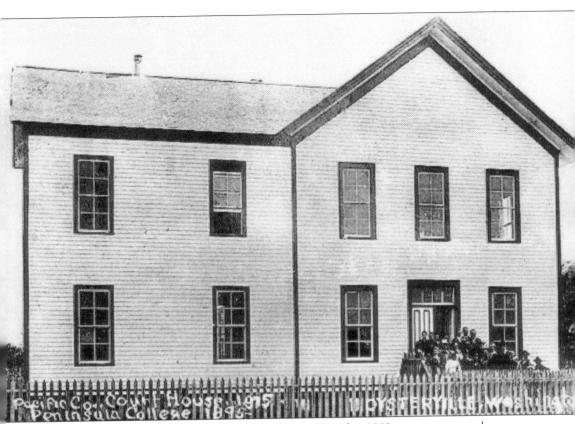

Pacific Co. Court House 1875
Peninsula College 1895-

Oysterville became the new seat of government in 1865, and in 1869 a two-story courthouse was built to house the records and court. By the 1890s, Oysterville was facing competition from South Bend and Nahcotta, which both wanted to become the new center of county government. In 1892, an election was held that reportedly made the new county seat South Bend. The legality of the election was questioned, but before anything could be done 85 South Bend citizens came to Oysterville on February 5, 1893, and stole all the county records. Several of the men kicked down the courthouse door and began to remove the records. It was reported that county auditor Phil D. Barney refused to give up the records in his possession and put up a good fight by hitting several South Benders over the head with a chair leg. Despite his protests, everything was taken except what was in the vault. It was later found that the election was illegal, but by then it was too late to reverse the decision.

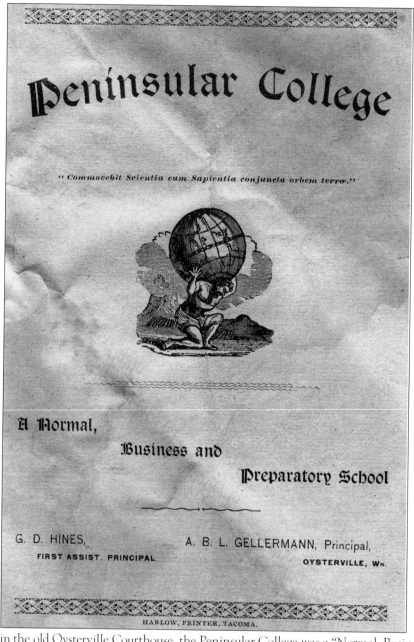

Peninsular College

" Commovebit Scientia cum Sapientia conjuncta orbem terræ."

A Normal,

Business and

Preparatory School

G. D. HINES,
FIRST ASSIST. PRINCIPAL.

A. B. L. GELLERMANN, Principal,
OYSTERVILLE, WN.

HARLOW, PRINTER, TACOMA.

Located in the old Oysterville Courthouse, the Peninsular College was a "Normal, Business and Preparatory School" established by A. B. L. Gellerman and opened on May 20, 1895. The tuition cost for the business and normal departments was $60 a year for 48 weeks of instruction, but prices varied depending on the type of instruction. Pamphlets advertised a dormitory and a variety of classes. Cost of boarding was from $1 to $3 per week. The college was quite liberal for its day and advertised that they "do not represent the old ironclad college government, nor do we believe in anarchy. We aim to so inspire the student with the desire to do just the right thing . . . we expect every man to be a gentleman and every woman a lady." Even though Gellerman had plans for expansion, the school closed after two years due to lack of enrollment. (Courtesy of Washington State Parks and Recreation Commission.)

Two

FROM HERE TO THERE

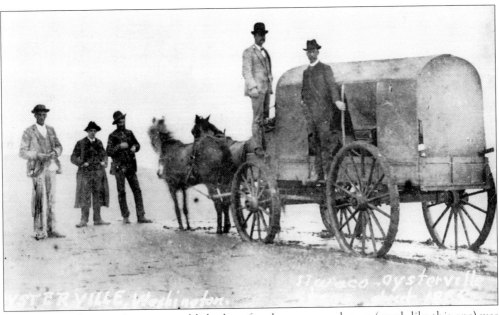

In 1870, a regular stage line was established—a four-horse covered stage (much like this one) was driven by Jonathan Stout. He loaded passengers from steamers by backing the wagon into Baker's Bay. Passengers could be loaded into rowboats and then transferred to the stage. From there, the stage traveled the plank road to the ocean beach. The stage ran according to the tide.

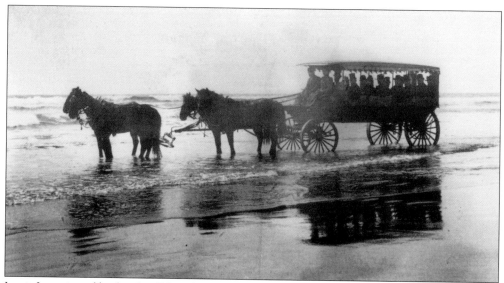

Lewis Loomis and his brother Edwin bought the beach stage line from Jonathan Stout. The route went from Ilwaco to Oysterville on the beach during low tide and was quite dangerous during winter storms when very large waves could hit the stage or horses. Loomis started out with a four-horse stage and eventually expanded to an eight-horse, five-seat stage that could carry up to 20 passengers. This photograph shows one of the sightseeing wagons that would take visitors up and down the beach to look at the many sights on the Peninsula.

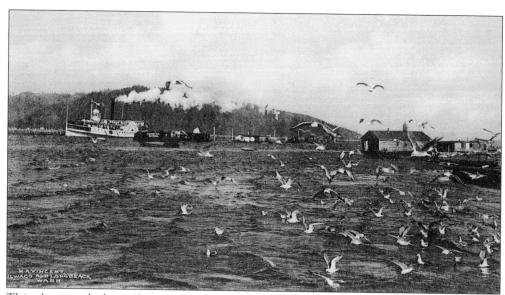

This photograph shows the *T. J. Potter* coming up the Columbia River. Also in view are the floating barges made to house the people and horses working the seining grounds on Sand Island. During low tide the barges sat on the sands, and during high tide they floated on the river. The *T. J. Potter* brought people from Portland, Oregon, to where they could catch the train to Peninsula destinations.

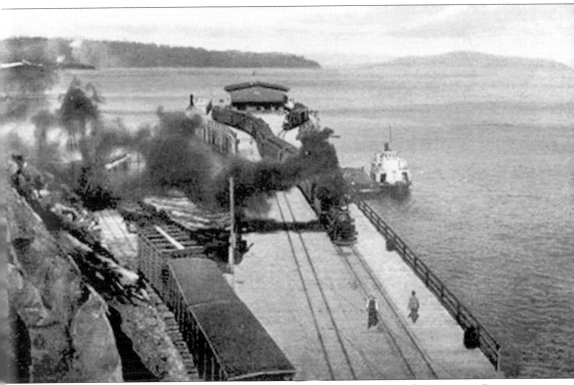

Megler was at one time the southern terminus of the Ilwaco Railroad and Navigation Company. The *T. J. Potter* operated between Portland and the Peninsula. It would dock and meet the train that was sometimes called the "Papa Train." It received this moniker because during the summer when families would stay at the beach, the men in the family would catch the train on Sunday and take the *T. J. Potter* into Portland. At the end of the week families would wait for "papa" to return on the *Potter* to the beach. The Ilwaco Railroad and Navigation Company had many nicknames besides the "Papa Train." It was also called the "Clamshell Railroad" and the "Irregular," "Rambling," and "Never-Get-There Railroad." The train ran on a very casual schedule and often stopped to allow passengers to picnic and fish.

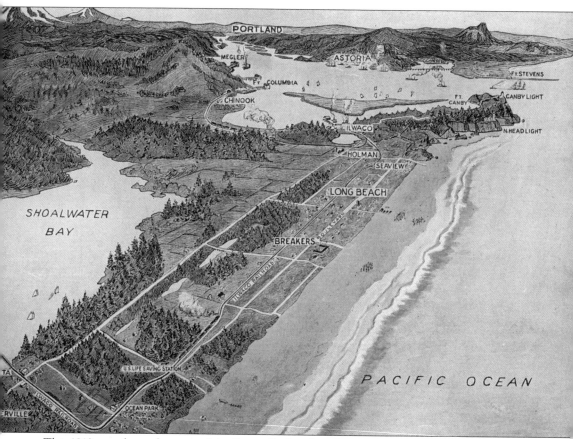

This 1910 map shows the route of the Ilwaco Railroad up the Peninsula and the various train stops along the way at Fort Columbia, Chinook, Holman, Ilwaco, Seaview, Long Beach, Breakers, Ilwaco Beach Life-Saving Station, Ocean Park, and Nahcotta. The train would often halt at various hotels and make unscheduled stops at scenic locations along the way. People who relied on the train for business and travel would many times complain about the casual way the railroad was run. It rarely ran according to a timetable, and the condition of the tracks made for a terrible bumpy ride. Many letters to the editor of the local paper complained about the lack of maintenance and lackadaisical manner of operation. The train made its last run in 1930.

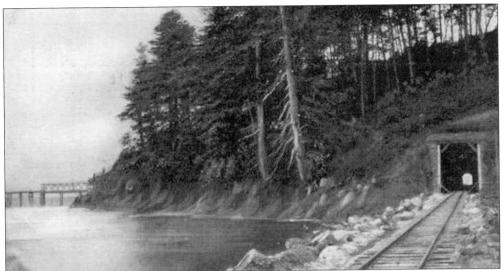

This early railroad tunnel, just east of Chinook, extends under Chinook Point and Fort Columbia. Originally, the tunnel was made of wood timbers but was later upgraded to a concrete tunnel. After the train ended operations in 1931, a highway was built through the tunnel for vehicle travel.

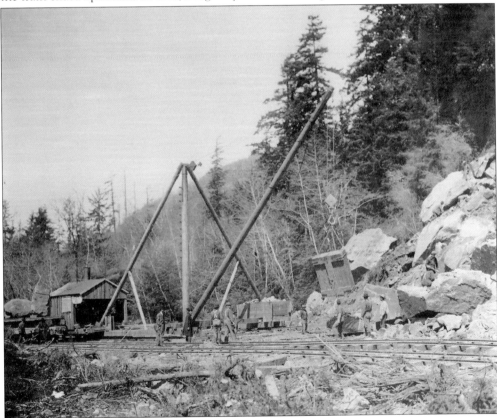

A crew of men work to quarry rock to put along the railroad to protect it from the Columbia River currents. Without this wall of rock, the roadway would have eroded into the river. One can still see the rock between Chinook Point and the Astoria-Megler Bridge.

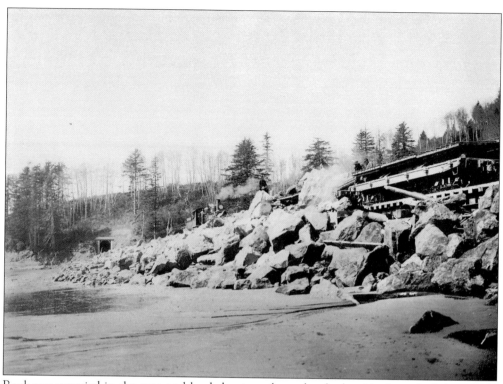

Rock was quarried in the area and loaded onto railcars that had a side dump bed that would tilt, allowing rock to slide off along the river. The rock ran along the railroad line to protect the tracks from erosion.

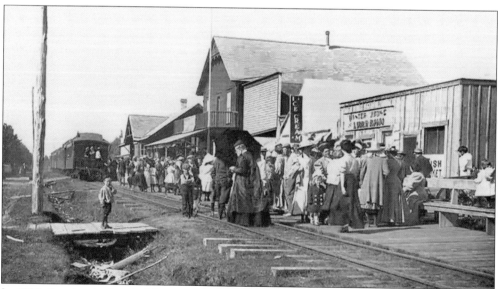

In 1908, Seaview had a vital business district surrounding the train depot where people would gather to do their business and meet or catch the train. In most communities, the arrival was a great social gathering.

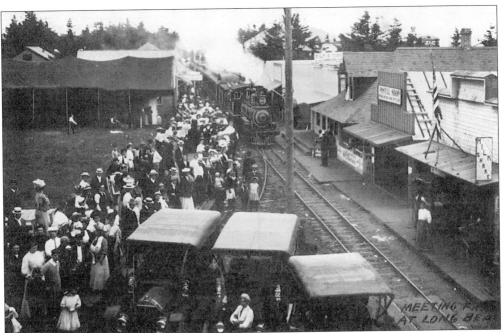

Meeting the train was an exciting event at all of the towns where stops were made. Cabs stood nearby to transport tourists to their hotels. Friends and relatives would see their loved ones off or greet them as they arrived. This early photograph of Long Beach shows many of the early shops. As vehicle traffic increased, the businesses were moved further back from the tracks to allow traffic to move through town.

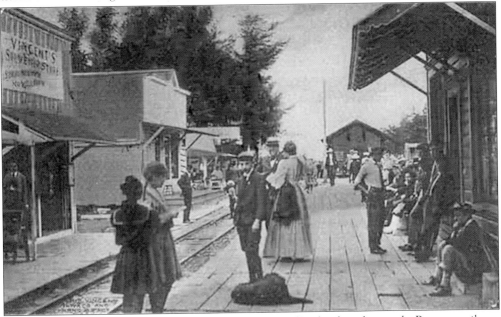

The railroad ran from Megler in the south to Nahcotta/Sealand in the north. Because rail was the most popular mode of transportation, the route included many stops along the way. The Long Beach Depot was one of those stops. Many people enjoyed sitting and watching the train and the colorful characters passing by.

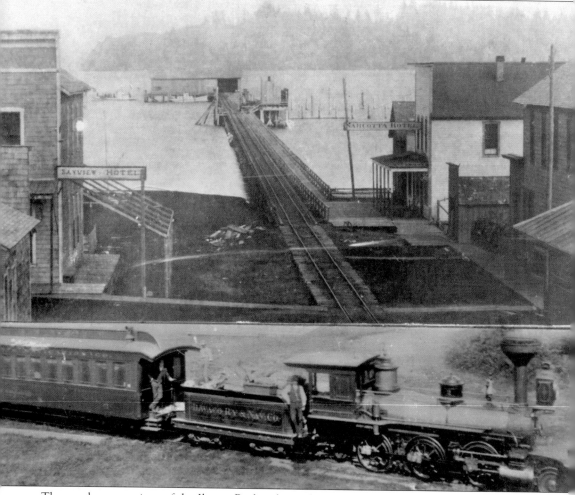

The northern terminus of the Ilwaco Railroad was the town of Nahcotta, named for local chief Nahcati. Originally, two communities formed around the location of the railroad tracks. John Peter Paul platted the town of Nahcotta and B. A. Seaborg platted Sealand. A controversy brewed between the two communities built by these competing businessmen. Each hoped their land would become the primary location of the railroad terminal as it was thought that the one that gained the terminal would become the primary destination for tourists on the bay. The Sealand Hotel was built along with several businesses, including the *Pacific Journal* and the post office, in Sealand. The Nahcotta Hotel, a general store, a railroad roundhouse, and shipping facilities were found in Nahcotta. As the result of a lawsuit, Nahcotta eventually became the end of the line for the train. (Courtesy of the *Ilwaco Tribune*.)

A popular way to travel from the north end of the Peninsula to the south was by driving on hard sand during low tide. This allowed cars to travel a straight pathway and gave the driver and passengers a front-row seat from which to beachcomb or enjoy the ocean view.

The old stage road originally ran from Ilwaco to the beach in the area of Willows Road. When automobiles became en vogue, the stage road was later extended via a plank road to North Head and eventually Fort Canby. The plank road was always in need of repair and was often fixed with planks taken from shipwrecks along the beach. The road offered both tourists and locals a scenic but very bumpy ride.

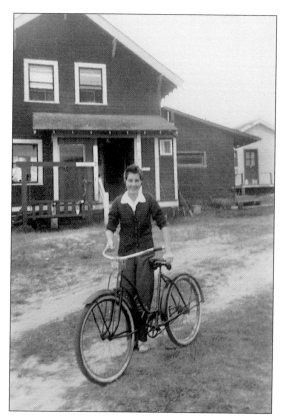

In the early days, the Peninsula was a great location for riding a bike because vehicle traffic was light. Whether up to the store, to visit a friend, or for enjoyment and exercise, it was a popular form of transportation. Biking on the hard beach sand or on the back roads to the lighthouses were popular activities.

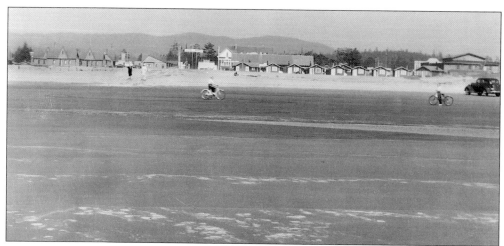

People walk and ride bikes on the hard sand of the beach. The Long Beach Hotel is visible in the background as well as several cottages built for visitors to stay in. The beach has always been a well-used path to reach destinations.

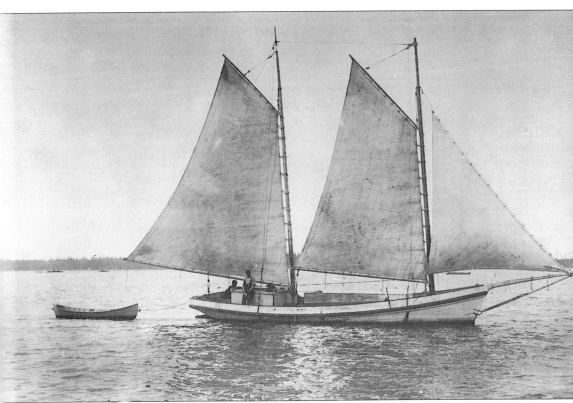

Sailboats could often be seen at full sail on Willapa Bay. The bay was a large body of water with strong enough winds to give boats the momentum needed to sail quite fast. Around 1872, the Shoalwater Bay Yacht Club in Oysterville scheduled its first regatta and races were held on the bay, followed by a fancy Regatta Ball. Oystermen would look forward to this day all year long and do their best to win the race. Often winners of the Shoalwater Bay competitions would also enter the Astoria Regatta and match their skills with other sailors in the area.

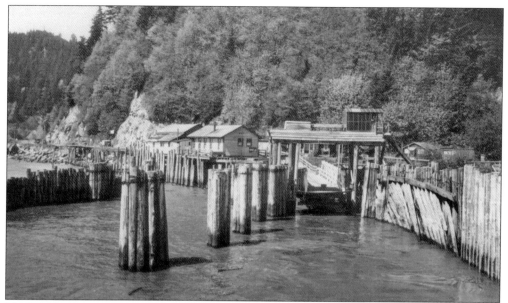

Megler, Washington, located on the Columbia River, was the site of the ferry docks. Ferries ran back and forth between Megler and Astoria, Oregon, from 1927 until 1966 when the bridge was built. Both foot passengers and cars could be transported. The approximately four-mile trip across the river took about 30 minutes on a "good day." Storms sometimes caused such rough water that the ferries would not be able to run. Occasionally the ferry would become stuck on sandbars and be delayed until it could float off at high tide.

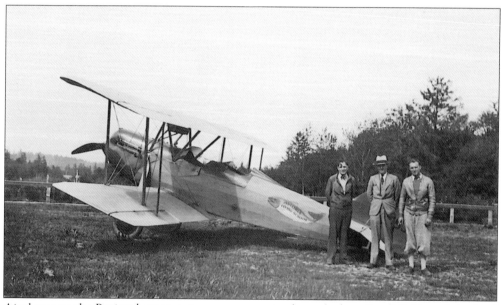

Airplanes on the Peninsula were not very common in the early days. Small fields and the hard sand on the beach were some of the few places planes could try to land. Travel by car and boat was slow, so flying was a quick alternative. The pilot of this plane was with the Astoria Flying School. (Courtesy of Sylvia Gensman.)

Three

GRAVEYARD
OF THE PACIFIC

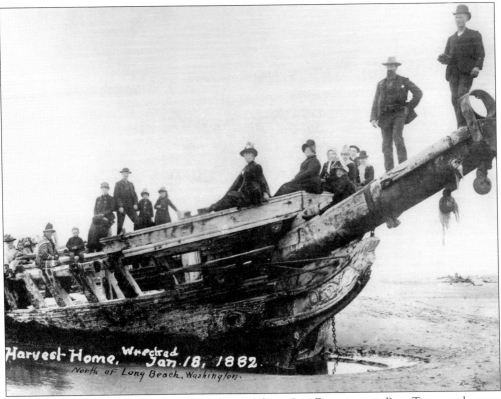

Harvest Home, Wrecked Jan. 18, 1882.
North of Long Beach, Washington.

The *Harvest Home*, an American bark headed from San Francisco to Port Townsend, came ashore eight miles north of Cape Disappointment at high tide in very heavy fog due to a faulty chronometer. When daylight came, all those aboard walked ashore at low tide. For years, the vessel was visited by thousands who summered at the beach. Wagons that were part of the cargo of the ship were salvaged and used by local farmers.

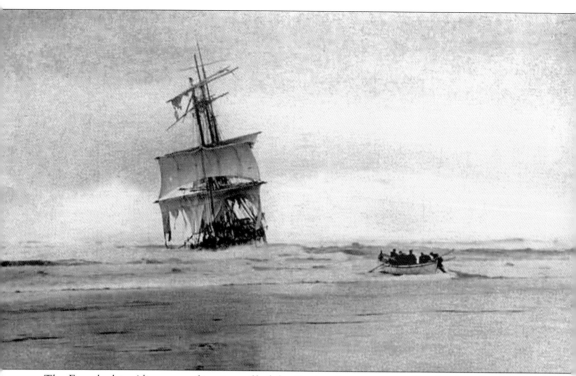

The French ship *Alice* was sailing just off of the Peninsula, en route to Portland on January 15, 1909, when she hit the sand off Ocean Park. The ship was loaded with 3,000 pounds of cement, which made it quite heavy in the surf. Alerted by his dog to the wreck, Willie Taylor contacted the Ilwaco Beach lifesaving crew. The crew hurried to the location of the wreck, but by the time they arrived, all of the people on the *Alice* were on the beach. A few days later, the Ilwaco Beach crew returned to assist the captain and several crew members in salvaging what they could from the ship. It was their last chance because the ship quickly sank into the sand and waves. The main mast was visible until about 1930 when it fell into the sea.

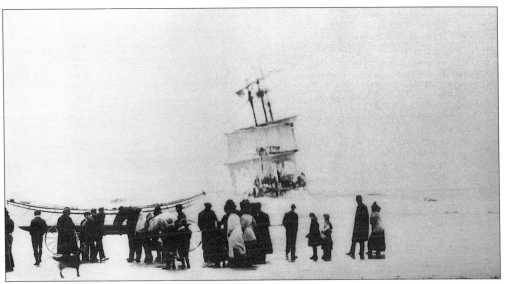

Here, people gather to look at the wreck of the *Alice*. On the left is one of the Ilwaco Beach lifesaving surfboats on the cart that was used to transport the boat. The lifeboat would be pulled either by the lifesaving crew or several horses. Occasionally the train that ran down the Peninsula would transport the cart and boat to the scene of a shipwreck.

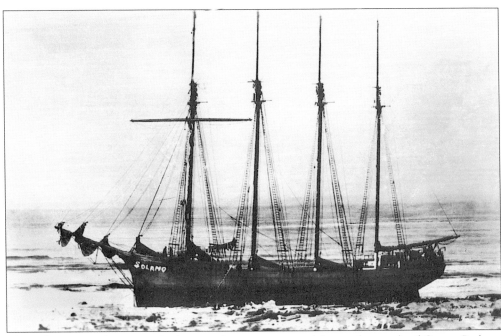

The *Solano* was a four-masted schooner that went aground four miles north of Ocean Park on February 5, 1907. Ilwaco Beach lifesaving crews responded to the distress signals, quickly made it to the shipwreck, and assisted all crew ashore. It was thought that the ship could be re-floated, but it was not to be and the ship became permanently stuck in the sand.

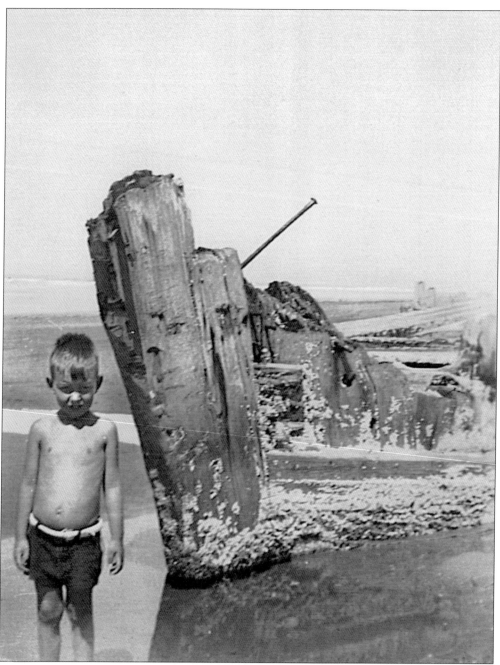

The *Solano* was known on the Peninsula as a ghost shipwreck because it quickly sank into the sand only to rise up several times over the years after storms. In 1923, the shipwreck disappeared under the sand for almost 10 years, but around 1932, when this photograph was taken, it became visible again. When the wreck was visible, it was a popular place for climbing and photo opportunities. In 1947, a group of people relaxing on the beach built a bonfire inside the hull. When they left, they didn't bother to extinguish the fire, and the wreck partially burned. Over time the weather and water consumed the wreck. It has now finally disappeared from sight. The ghost shipwreck has permanently gone to its watery grave.

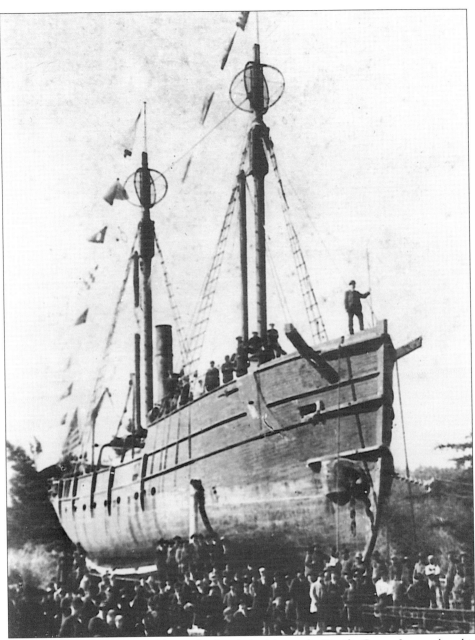

Columbia River Lightship No. 50 was the first lightship on the Pacific Coast. It was placed into service at the mouth of the Columbia River in 1892. At 112 feet long, the ship was powered by sail and equipped with two boilers that furnished steam for the 12-inch fog whistle and for hoisting the large lamps up the masts. On November 28, 1899, the lightship was caught in a storm that caused her to slip the cables anchoring her in place. Despite attempts to rescue the drifting ship, it went aground just off McKenzie Head. After several months, it was determined that the lightship could not be pulled out into the ocean but that it could be possible to move her forward across the isthmus to Baker's Bay. Using horses to pull the ship over a road made of timbers, it took 16 months for the ship to be re-floated into the bay. After receiving repairs, the lightship was placed back in service at the mouth of the Columbia River until its retirement in 1909.

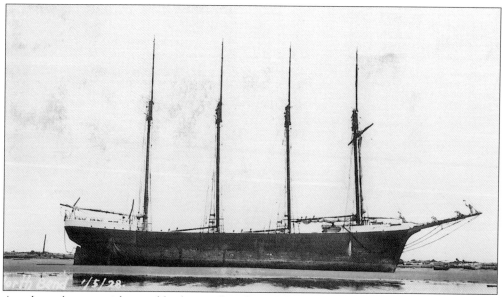

Another schooner with an odd tale to tell is that of the *North Bend*. On January 5, 1928, the ship was headed to Astoria, and while crossing the Columbia River bar, the wind suddenly died. Without power the ship began to drift and finally went aground on Peacock Spit.

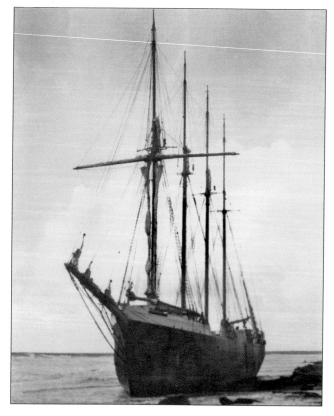

After several attempts to pull the *North Bend* off a sandbar, the crew was removed from the ship. The wind and high waves continued to push at the *North Bend* and by February 11, 1929, she was re-floated on Baker's Bay. The wind and water had formed a channel in front of the ship and pushed it over a half-mile to the bay with very little damage.

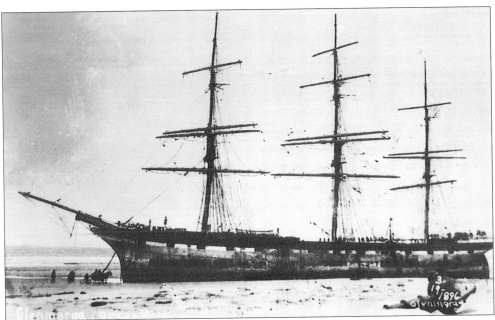

The *Glenmorag* was sailing off the Columbia River bar in thick fog with very little wind. Pushed by northerly currents, the ship ran aground near Ocean Park. Two of the crew were killed and others were injured as they attempted to reach shore. After efforts were made to pull the ship off the beach, it finally came to rest and was slowly swallowed by the sand.

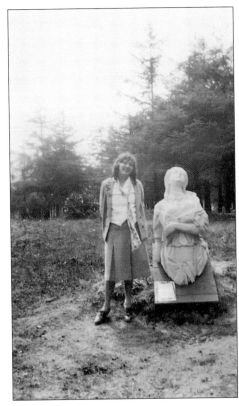

The figurehead of the *Glenmorag* was salvaged by William Begg, one of the crew of the ship. For a while it rested at Morehead Park in Nahcotta. Here, Sylvia Gensman has her photograph taken with the figurehead at the park. It was eventually removed by Begg's family and taken to their home in Vancouver, Washington. (Courtesy of Sylvia Gensman.)

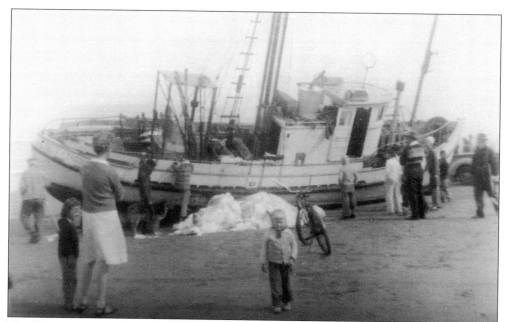

The *Troy* went aground at Long Beach on August 31, 1946. The boat suffered little damage and became quite an attraction as it sat on the beach at low tide. It eventually became the second boat removed from a weather beach. The first was the schooner *Zampa* in 1904. The photograph shows the *Troy* on the sand and many of the people who came to see it before it was pulled off the beach.

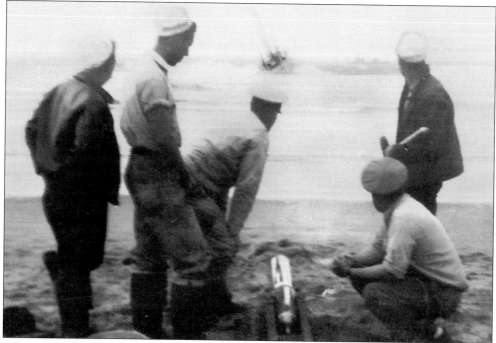

When the *Troy* went aground, it was high tide. The Coast Guard was called and came to assist the crew and boat to safety. The Cape Disappointment Coast Guard crew in this photograph is attempting to shoot a safety line to the stranded troller with a lyle gun.

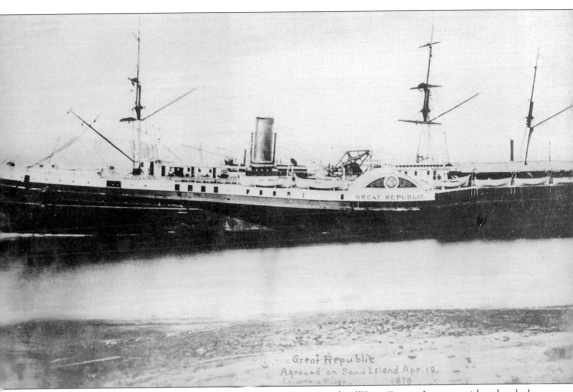

Great Republic
Aground on Sand Island Apr. 19,
Columbia River. 1879

The *Great Republic* was the largest passenger steamer on the West Coast. It was a side-wheeled steamship, 378 feet long, and could make the Portland-to-Astoria run in 5 hours and 15 minutes. The ship wrecked on Sand Island on April 19, 1879, with 896 passengers aboard plus crew. The 550 cabin passengers each paid $5 for a cabin; the 346 steerage passengers paid $2.50 for passage. The *Republic* was attempting to cross the Columbia River bar at night when it came too close to the shallow channel and grounded on Sand Island. Four tugs were able to rescue many of the passengers. As the ship started to break apart, the remaining passengers and many of the crew were evacuated to Sand Island. One of the last lifeboats to leave was hit by a wave and capsized, drowning 11 crew members. For years, Fort Canby gunners used the wreck of the ship for target practice. The area of Sand Island the ship went aground was known as "Republic Spit."

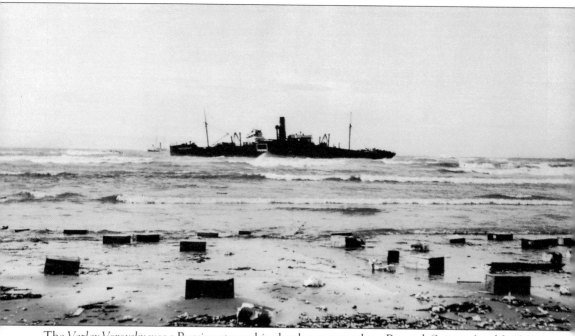

The *Vazlav Vorovsky* was a Russian steamship that became stuck on Peacock Spit on April 3, 1941. It was headed out over the bar carrying machinery, lard, and other food commodities when it ran into heavy seas and gale-force winds. When the steering jammed, the anchors were dropped. The anchors were not able to hold and the *Vazlav Vorovsky* went aground on the spit. The Coast Guard was immediately sent to the scene and safely rescued the crew. At that time the captain refused to leave his ship. It was a day later before he knew that his vessel was doomed and requested to be evacuated. The ship continued to break up, spilling some of its cargo into the surf. In this photograph, some of the boxes of lard have washed up on the beach.

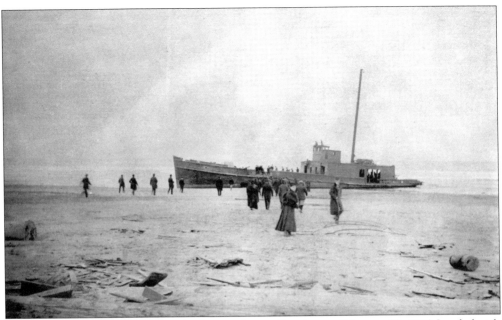

The *Point Loma* went aground on the Peninsula near Seaview on February 28, 1896. Loaded with lumber, the ship ran into foul weather. Water leaking into the ship put out the steamer's boilers and the powerless vessel drifted towards the beach. The lifesaving crew fired their lyle gun and a line to the ship, and the ship's crew was able to escape.

The schooner *Zampa* became stranded at Leadbetter Point on July 17, 1904, because she lost her rudder during a storm. After going aground on the sand, the vessel was re-floated a few months later. She was the first ship to be removed from a weather beach on the Peninsula. Usually once a ship is grounded, begins to sink into the sand and cannot be removed.

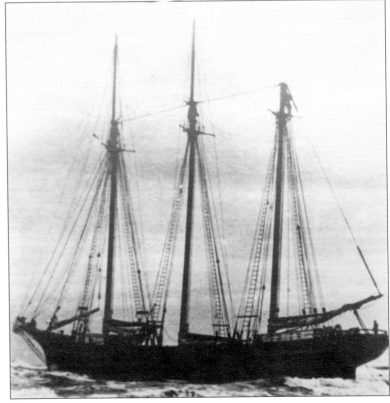

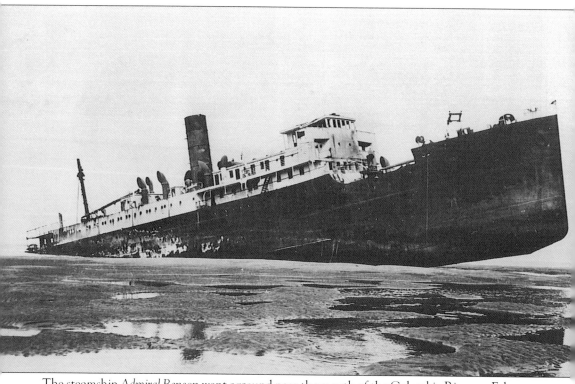

The steamship *Admiral Benson* went aground near the mouth of the Columbia River on February 15, 1930, during stormy and foggy weather. Conditions worsened, and waves began to tear the ship apart. The Coast Guard evacuated the 104 survivors by lifeboats. The beach just north of the jetty was named Benson Beach after the ship that wrecked on its sands.

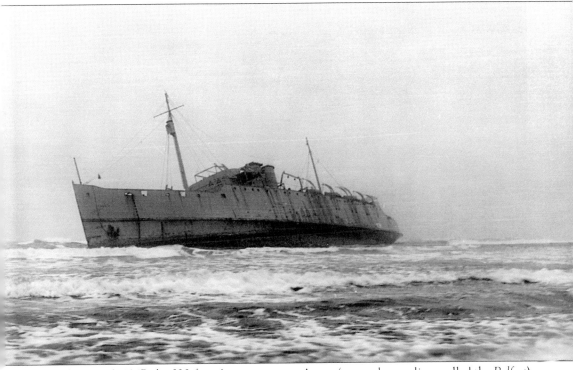

On February 13, 1947, the 320-foot Army transport *Arrow* (once a luxury liner called the *Belfast*) was being towed by a tug to Tongue Point, near Astoria, Oregon. During World War II, the Army purchased the liner and put it into service as a ferry in the Hawaiian Islands. After the war, it was no longer needed so and so was considered surplus military equipment. As the tug and the *Arrow* approached the Columbia River, the seas became very rough and the towline from the tug to the *Arrow* came apart several times. The final time the towline broke, the transport was pushed to the beach by the waves. The ship went aground near the Cranberry Road approach. Many local residents knew the vessel was aground before the Coast Guard did. Because it was stuck so fast into the sand, all hope of pulling the *Arrow* out was lost.

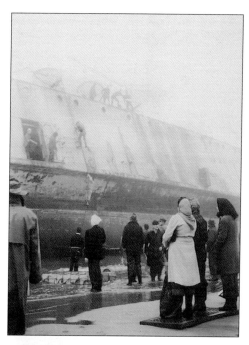

For a while, the military guarded the deactivated Army transport *Arrow* to prevent sightseers and beachcombers from taking anything off the ship. After hope of pulling the *Arrow* off the sands was gone, the Army recalled the troops and left it for people to salvage what they wanted.

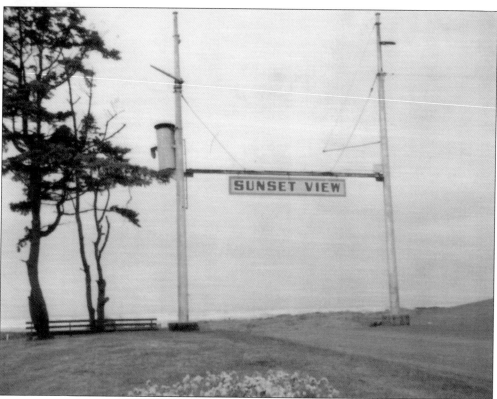

After the grounding of the transport ship *Arrow*, the masts were removed and taken to Ocean Park at the north end of the Peninsula where they were installed at the entrance to the beach as a war memorial. Many dignitaries attended the dedication ceremony.

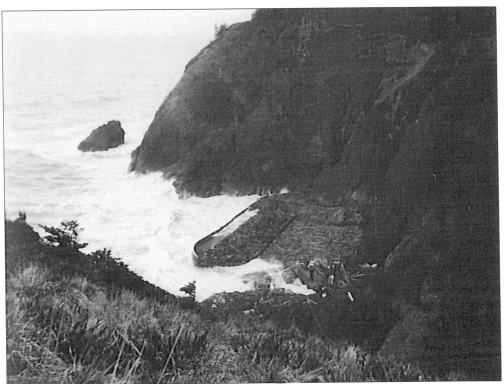

Pictured here is Barge No. 1684 and its load of lumber being tossed around by the waves in the small cove. Much of the lumber eventually came up on the Peninsula beach as broken and rounded pieces of wood.

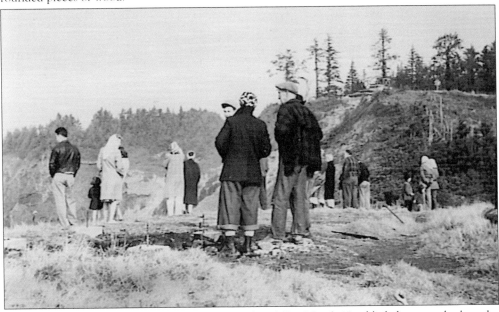

In this photograph, people have gathered near the cliff at North Head lighthouse to look at the small cove on the north side of the lighthouse, where a lumber barge is being smashed against the rocks.

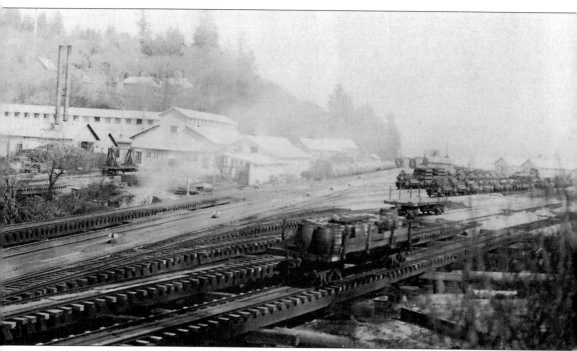

In order to control the channel of the Columbia River and make it safer for ships, jetties were built on both the north and south sides of the river. Construction of the south jetty began in 1885 and on the north jetty in 1914 (completed in 1917). To support the construction, housing, work buildings, water and sewage facilities, and a railway had to be built. These support facilities kept the large construction project going. In order to put down the rock, pilings were driven along the path of the jetty for a length of approximately 2.3 miles. A track was installed on the trestle to form a railway for a small engine and the rock-hauling rail cars to travel on. In this photograph, many of the support buildings and the railway system that brought rock to the jetty are visible. (Courtesy of Washington State Parks and Recreation Commission.)

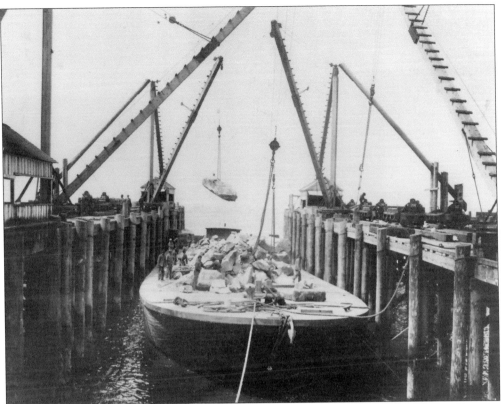

Barges floated rock down the Columbia River to the Fort Canby dock on Baker's Bay. Here the rock was hoisted from the barge and onto rail cars. The small train would pull the cars out over the water and dump the rocks on either side of the tracks. As they piled up, the rocks formed the north jetty. (Courtesy of Washington State Parks and Recreation Commission.)

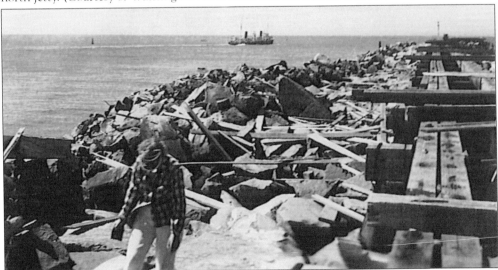

The final length of the north jetty was approximately 2.3 miles; it was 30 feet high, 25 feet wide, and constructed of nearly 3 million tons of rock. Here, people gather lumber that washed up on the north jetty. The wooden portion of the tracks held the rails for the jetty train.

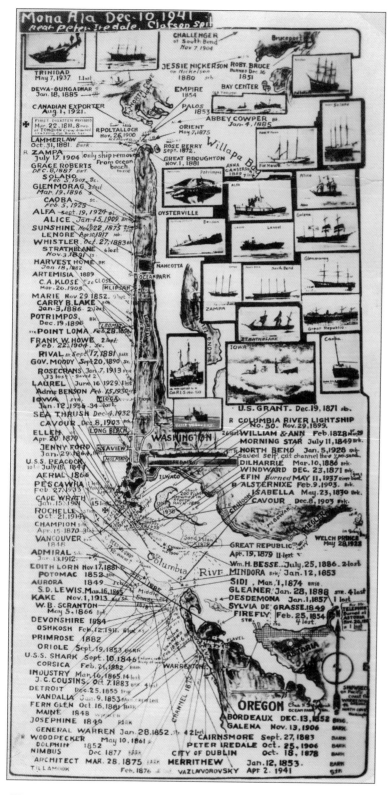

Mona Ala Dec. 10 1941
near peter iredale, Clatson Spit

CHALLENGER
at South Bend
Nov 7, 1904

Bruceport

TRINIDAD
May 7, 1937 t.lost

DEWA-GUNGADHAR
Jan. 18, 1885

CANADIAN EXPORTER
Aug. 1, 1921.

JESSIE NICKERSON ROBT. BRUCE
on Nickelson Burned Dec 16
1880 sch 1851

EMPIRE
1854

BAY CENTER

PALOS
1853

ABBEY COWPER Br.
Jan. 4, 1885.

Solano

FIRST DISASTER RECORDED
Mar. 22, 1811. 8 men
of TONQUIN Crew drowned
in attempting Col. River bar

R. POLTALLOCH
Nov. 26, 1900

ORIENT
May 7, 1875

LAMMERLAW
Oct. 31, 1881 Bark.

R ZAMPA
July 17, 1904 only ship removed
 From ocean
GRACE ROBERTS beach.
DEC. 8, 1887 BRT.

ROSE BERRY
Sept. 1872.

GREAT BROUGHTON
Nov. 1, 1881

Willapa Bay

SOLANO
Dec. 5, 1907. Sc.

ANNA
GANDERS B.CO.
(1869 ?) 7 lost

GLENMORAG 21st
Mar. 19, 1896.

Alice

CAOBA Sc.
Feb. 5, 1925

ALFA — Sept. 19, 1924 sc.

OYSTERVILLE

ALICE Jan. 15, 1909 Br.

SUNSHINE Nov. 22, 1875

LENORE Apr. 10, 1917 Mb.

Galena

WHISTLER Oct. 27, 1883 sh

STRATHBLANE
Nov. 3, 1891 6 lost

Laurel

HARVEST HOME BK
Jan. 18, 1882

NAHCOTTA

ARTEMISIA 1889

C.A. KLOSE sc CLOSE
Mar. 26, 1905

OCEANPARK

Glenmorag

KLIPSAN

MARIE Nov 29 1852. 9 lost

CARRY B. LAKE
Jan. 3, 1886 2 lost.

LOOMIS

North Bend

POTRIMPOS BK
Dec. 19, 1896

POINT LOMA Feb. 28, 1896

FRANK W. HOWE 2 lost
Feb. 22, 1904 sc.

BARK

IOWA

RIVAL Br Sept 17, 1881

Great Republic

GOV. MOODY Sept 20, 1890 sc

ROSECRANS Jan. 7, 1913 str
 33 lost Saved 2

LAUREL June 16, 1929. 1 lost

Admr BENSON Feb. 15, 1930 sc

STRATHBLANE

Caoba

IOWA STR.
Jan. 12, 1936. 34 lost.

IOCA

SEA THRUSH Dec. 4, 1932

CAVOUR Dec. 8, 1903 br

LONG BEACH

U.S. GRANT. Dec. 19, 1871 st.

R COLUMBIA RIVER LIGHTSHIP
 No. 50 Nov. 29, 1899.

PETER IREDALE

ELLEN
Apr. 20, 1870

WASHINGTON

26 lost WILLIAM & ANN Feb. 1828 N. 29

MORNING STAR July 11, 1849 brk.

JENNY FORD
Jan. 29, 1864.

SEAVIEW

HOLMAN

NORTH BEND Jan. 5, 1928 sch
Saved self, cut channel thru ½mi sand.

U.S.S. PEACOCK
10 l July 18, 1841

ILWACO

DILHARRIE Mar. 10, 1880 brk.

WINDWARD DEC. 23, 1871 br.

AERIAL 1886

PESCAWHA
Feb. 27, 1933

EFIN Burned MAY 11, 1937 river boat

B ALSTERNIXE Feb. 9, 1903. Brk.

CAPE WRATH
Jan. 15, 1901 151

ISABELLA May. 23, 1830 Brk.

ROCHELLE
Oct. 21, 1914

CAVOUR Dec. 8, 1903 Br.

CHAMPION sh
Apr. 15, 1870 3 lost

VANCOUVER brg
1848

Columbia

WELCH PRINCE
May 28, 1922

GREAT REPUBLIC STR.
Apr. 19, 1879 11 lost

ADMIRAL sch.
Jan. 13, 1912.

River

Wm. H. BESSE July. 25, 1886. 2 lost

EDITH LORN Nov. 17, 1881

MINDORA Brk. Jan. 12, 1853

POTOMAC 1852

SIDI Mar. 1, 1874 BRIG

AURORA 1849 sch

GLEANER Jan. 28, 1888 STR. 4 lost

S.D. LEWIS Mar. 16, 1865

DESDEMONA Jan. 1, 1857 1 lost

KAKE Nov. 1, 1913 br. St.

SYLVIA DE GRASSE 1849

W. B. SCRANTON
May 5, 1866 Brk.

FIREFLY Feb. 25, 1854 STR.
 4 lost.

DEVONSHIRE 1884

OSHKOSH Feb. 12, 1911 61 st

PRIMROSE 1882

ORIOLE Sept. 19, 1853 BARK

U.S.S. SHARK Sept. 10, 1846

CORSICA Feb. 21, 1882 BARK

FLAVEL

INDUSTRY Mar. 16, 1865 14 lost

WARRENTON

J. C. COUSINS Oct. 7, 1883 Brk 4 lost

DETROIT Dec. 25, 1855 brig

VANDALIA Jan. 9, 1853 BARK

FERN GLEN Oct. 16, 1881 BARK

MAINE 1848

OREGON

JOSEPHINE 1849 BARK

BORDEAUX DEC. 13, 1852 BRIG.

GENERAL WARREN Jan. 28, 1852. 42 lost

GALENA Nov. 13, 1906 BARK

R WOODPECKER May 10, 1861

CAIRNSMORE Sept. 27, 1883 BARK

DOLPHIN 1852

PETER IREDALE Oct. 25, 1906 BARK

NIMBUS Dec 1877 BARK

CITY OF DUBLIN Oct. 18, 1878 BARK

ARCHITECT MAR. 28, 1875 BARK

MERRITHEW Jan. 12, 1853. BARK

TILLAMOOK Feb. 1876

VAZLAVOROVSKY Apr 2. 1941 STR.

This shipwreck map by Charles Fitzpatrick was one of many maps put together and sold to show both residents and visitors where the shipwrecks were on the Peninsula and at the mouth of the Columbia River, called "Graveyard of the Pacific." This map also contained photographs of some of the shipwrecks and included the names and dates of each wreck. Books that told the history of these shipwrecks were also very popular. In the early days, maps helped identify a wreck that might be seen on the beach or give a location to those who enjoyed seeking them out. Today, the shipwrecks along the Peninsula beach are buried and no longer visible.

Four

SOLDIERS AND SAILORS

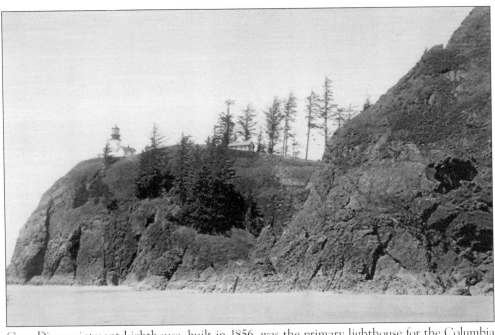

Cape Disappointment Lighthouse, built in 1856, was the primary lighthouse for the Columbia River bar until North Head Lighthouse was built in 1898. It replaced notched trees, white flags, and bonfires as a marker for the Columbia River. The tower stands 53 feet high, and the focal plane of the light is 220 feet above sea level.

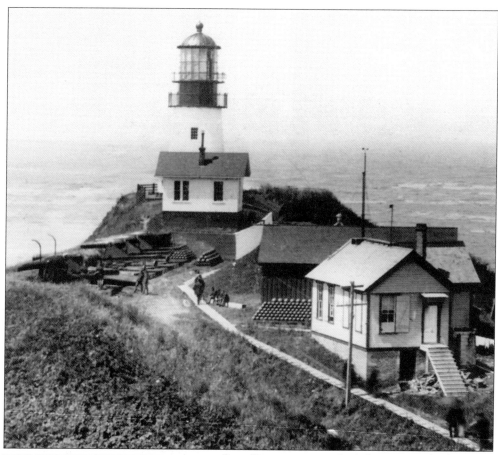

Cape Disappointment Lighthouse was also known as Fort Canby light. It was the site of one of the first of three military batteries built during the Civil War era. Mounted at "Lighthouse Battery" were two eight-inch guns, four 10-inch guns, and one 15-inch Rodman.

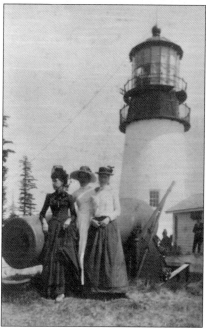

On nice days, one activity many enjoyed was to pack a picnic lunch and head up to either North Head or Cape Disappointment Lighthouses. These women, dressed up for a fine day, pose in front of Cape Disappointment Lighthouse next to the 15-inch Rodman smoothbore gun that was installed as part of "Lighthouse Battery."

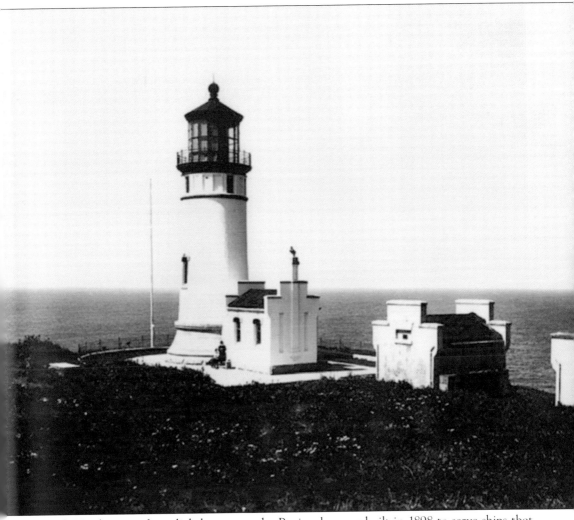

North Head—one of two lighthouses on the Peninsula—was built in 1898 to serve ships that were coming from the north and could not see Cape Disappointment Lighthouse in time to turn into the Columbia River channel. This error in not making the channel was the cause of several shipwrecks. North Head's tower is 65 feet high and stands 194 feet above the water line. When the lighthouse was built, it held the first order Fresnel lens that had been installed in Cape Disappointment Lighthouse when it was constructed in 1856. The lens had originally been installed at Navsink Lighthouse on the East Coast. According to official records, North Head is claimed to be one of the windiest places on the West Coast. This location is also one of the foggiest, with an average of 160 foggy days each year.

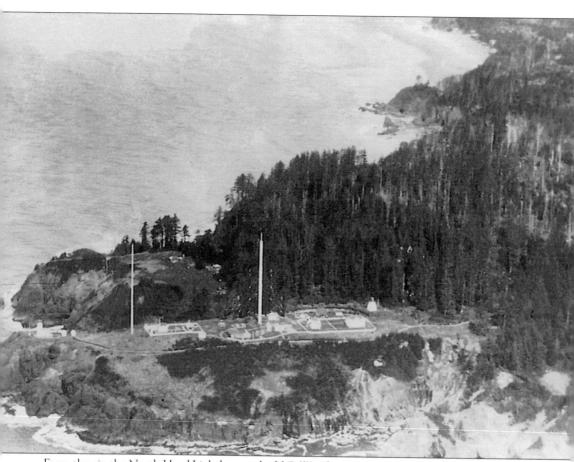

From the air, the North Head Lighthouse, the U.S. Weather Bureau station, and the wireless signal station can be seen. Also, within view are several military buildings and the lighthouse keepers' residences. The official weather station located at North Head was staffed 24 hours a day and communicated weather and surf conditions to Portland every four hours. An interesting incident happened on January 5, 1906, when the station was destroyed by a lightning strike when a bolt hit the tower, came through the roof, and burned out the wiring. Another bolt came through the window and destroyed the instruments. Mr. Kelliher, the staff person for the weather bureau, was also injured. The station was out of commission for approximately two weeks following this force of nature. Several years later, a wireless signal station was built. It provided weather information to the batteries of Fort Canby and to passing ships, and it was able to send and receive messages up to 3,000 miles away. An upgrade to the station completed in 1912 allowed the signal to carry for up to 6,000 miles.

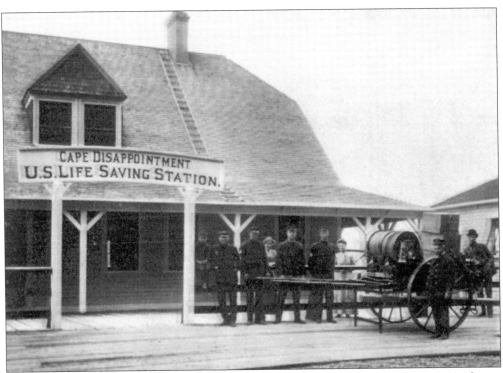

Cape Disappointment U.S. Life-Saving Station was built in 1878 at the old Fort Canby on Baker's Bay. The top photograph shows some of the crew standing in front of the station along with a line cart that holds the line used to rescue people from ships. The bottom photograph shows the south side of the station. This view shows how it was built on pilings over the water. In 1877, lighthouse keeper Joel Munson started a volunteer station. It was not until 1882 that a full-time crew replaced the volunteers. Eventually all U.S. Life-Saving Service stations came under the supervision of the U.S. Coast Guard. This site is currently U.S. Coast Guard Station Cape Disappointment.

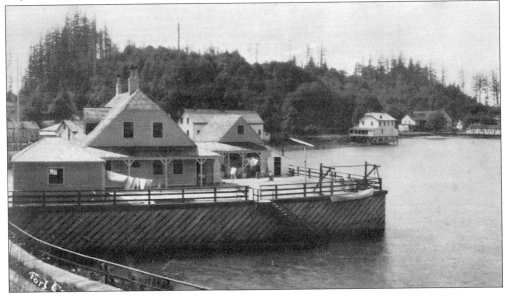

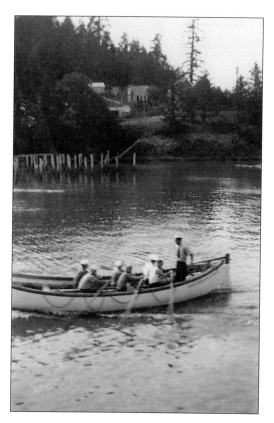

The Cape Disappointment lifesaving crew is pictured doing practice drills in Baker's Bay around 1930. Part of the old jetty construction housing can be seen in the background. In the early days, a rowing lifeboat was used. Some of the boats also had a mast and sail that could be raised if needed to get to a rescue.

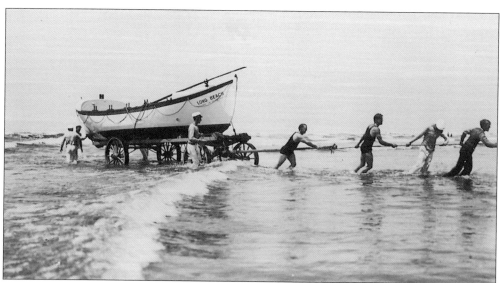

This lifesaving crew on the Peninsula pulls the boat out of the water. On a rescue, the crew would push the boat out into the breakers and six surf men would row out to the ship. In returning, the cart would be pushed into the breakers and the boat loaded on it. Either the surf men or horses would then pull the cart out of the water.

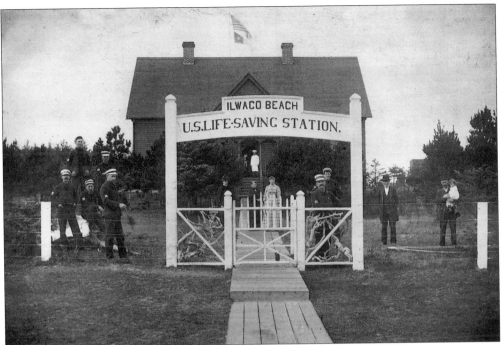

The Ilwaco Beach Life-Saving Station was located at what is now called Klipsan Beach. This station, established in 1889, was the second one built on the Peninsula. The station was manned by volunteers when it was activated. On November 3, 1891, the British ship *Strathblane* struck the sand near the station. The crew was unable to get their lines to the ship, and seven people died. Because of this tragedy, by 1892, a full-time crew was assigned. (Courtesy of MSCUA, University of Washington Libraries.)

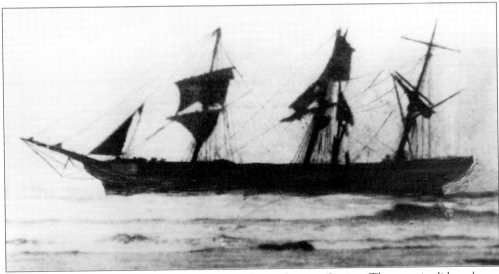

The *Strathblane* wrecked just south of Ocean Park near Loomis Station. The captain did not know that his chronometer was faulty and thought he was 60 miles off shore when he struck the sand of the Peninsula. Seven lives were lost as the crew tried to make it to shore. Because of this wreck, Ilwaco Beach Life-Saving Station was converted from a volunteer unit to paid lifesaving crews.

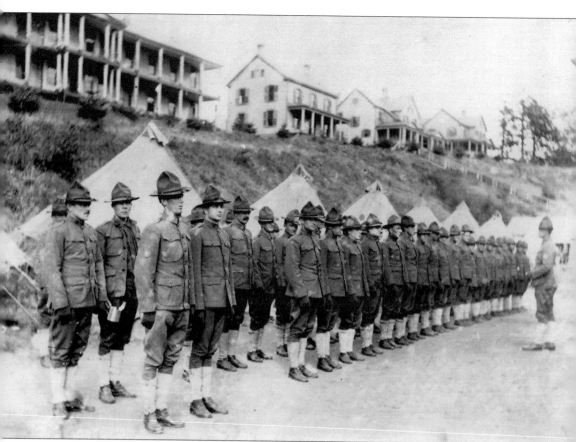

Fort Columbia was one of three coastal artillery forts guarding the Columbia River, located just east of the town of Chinook. Construction began in 1896 and upgrades and building occurred off and on until 1941. Fort Columbia had several guns and controlled the mines that crossed the shipping lanes on the river. The first battery built at Fort Columbia was Battery Ord. It was named after Lt. Jules G. Ord, who was killed in the Spanish-American War. By 1900, two additional batteries were built: Battery Murphy and Battery Crenshaw. They were also named after soldiers who died in the war. This photograph shows National Guard soldiers with their tents. For several years, they trained at Fort Columbia during the summer. Military barracks and houses appear in the background. (Courtesy of Washington State Parks and Recreation Commission.)

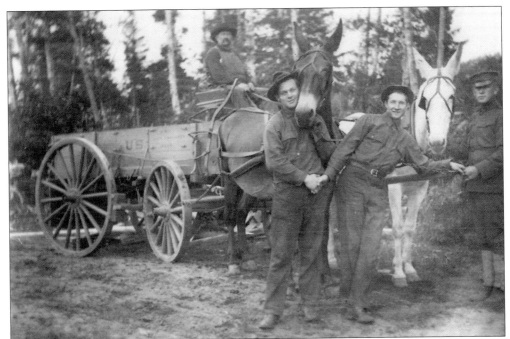

This group of Fort Columbia soldiers poses with an Army wagon and mule, a method used to transport items needed for the fort. Fort Columbia experienced several active periods during the wars, as well as inactive periods where only a few people kept the place maintained. (Courtesy of Washington State Parks and Recreation Commission.)

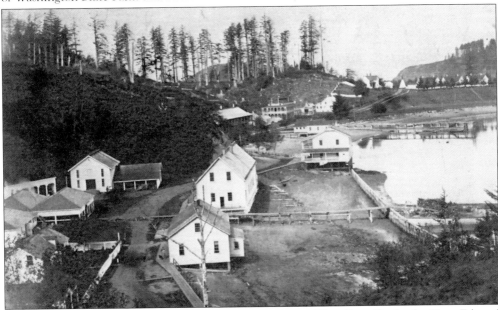

The name Fort Cape Disappointment was changed in 1875 to Fort Canby for Gen. Edward Richard Sprigg Canby, who died in the Modoc Wars. Construction for the fort began in 1862 during the Civil War. The officer's quarters were built in 1864, the wharf in 1871, and in 1874 troops from the fort built a road from Fort Canby to Ilwaco. It was deactivated in 1947. (Courtesy of Washington State Parks and Recreation Commission.)

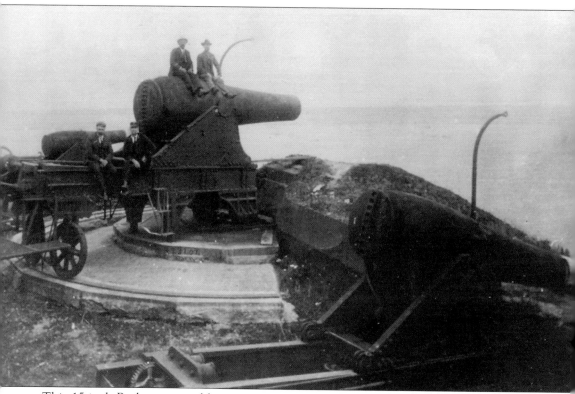

This 15-inch Rodman smoothbore cannon was moved to Center Battery overlooking the Columbia River. It was originally part of the Lighthouse Battery and was mounted in front of Cape Disappointment Lighthouse, facing west. It was moved because percussion from the firing gun cracked the glass in the lighthouse and the lighthouse keeper became angry and filed a complaint. Until the gun was moved, the soldiers were not allowed to use it. The Rodman could shoot a 315-pound projectile as far as two miles, or a projectile as large as 450 pounds a shorter distance. This cannon weighed 50,000 pounds. It is thought that when the cannon became obsolete and was no longer needed, it was pushed over the side of the cliff into the Columbia River. (Courtesy of Washington State Parks and Recreation Commission.)

Five

BOUNTIFUL HARVEST

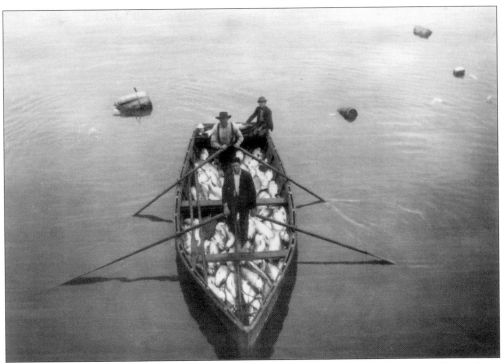

Fishermen with a boat full of salmon return from the fish traps on the Columbia River about 1897. The traps became a popular and lucrative means of fishing, particularly in Baker's Bay between Chinook and Ilwaco. Salmon were trapped and then put into boats to be delivered to fish buyers.

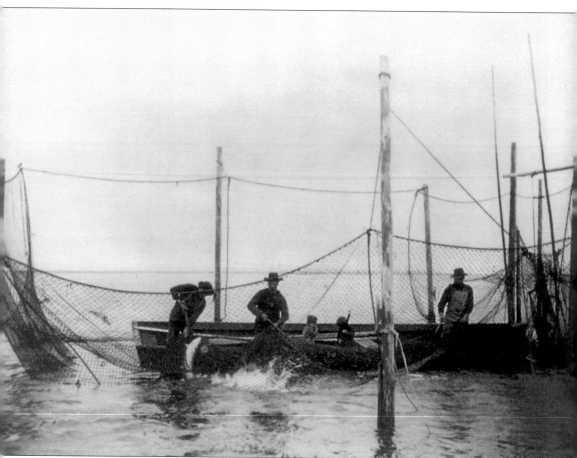

Scandinavian fishermen introduced fish traps to the Chinook area in the 1800s. Hundreds of traps were built along the Columbia River between Chinook and Ilwaco, until by 1892 there were approximately 378 traps in the area. This method of fishing became so successful that those who owned traps became very wealthy. In this photograph, working the fish traps seems to be a family affair. Two children sit quietly in the boat watching their father bring in the catch. Fish traps also brought much controversy; gillnetters felt the traps were catching most of the salmon and blamed the traps for the decline in gillnet fisheries. There were many fights; traps were damaged; and people were hurt or killed over fishing rights and the decline of salmon in the Columbia River. (Courtesy of MSCUA, University of Washington Libraries.)

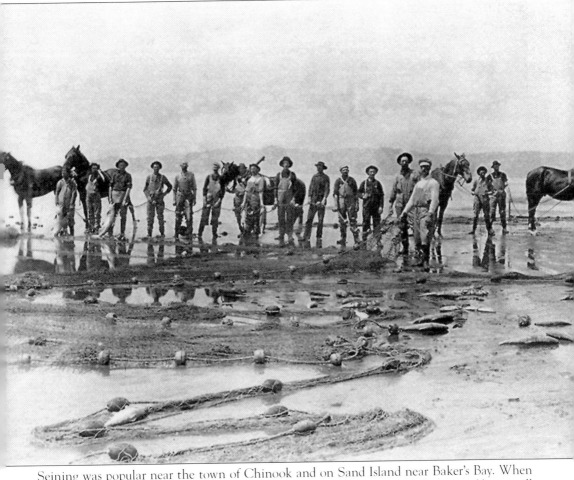

Seining was popular near the town of Chinook and on Sand Island near Baker's Bay. When seining, long nets were dropped in the water and the end of the net was pulled around by a small boat to make a purse. Men or horses pulled the fish-filled nets into shore. In the early years, seine crews included 20 to 40 men and five to seven teams of horses. Seiners were always in competition with gillnetters and trappers for both fish and fishing areas. It was common during this time to see floating cabins in the middle of the river. The fish crews and horses that worked on Sand Island or Peacock Spit would sleep and eat there while waiting for low tide. When able to move about, the men and horses went to work.

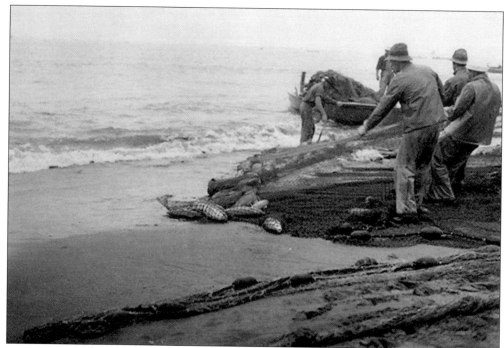

Seine crews included approximately 20 to 40 men and five to seven teams of horses. Fish were caught in large nets in the Columbia River, and then pulled ashore by men and horses. Early fishermen learned to seine from the Chinook, who fished this area for generations.

Sand Island, located in the Columbia River near Chinook, was a popular location where fishermen seined for fish. This floating cabin offered protection from the weather and a place to cook and sleep during high tide. Fishermen found the morning low tide the best time to seine. (Courtesy of MSCUA, University of Washington Libraries.)

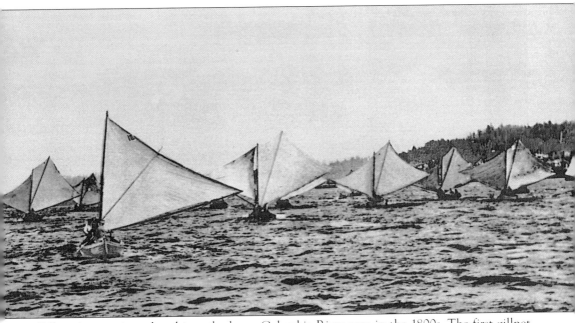

Gillnetting was introduced into the lower Columbia River area in the 1800s. The first gillnet boats were powered by sail and measured about 25 feet long, 6 feet wide, and 2.5 feet deep. The fleet of gillnet boats was often called the "butterfly fleet" because the sails made the boats look like butterflies. Early gillnetters fastened floats to nets as long as 1,400 feet and 25 feet deep, which caused the net to float on the surface. Weights were attached to the bottom to hold it down. The gillnet fishermen worked mostly at night because they claimed the fish could see the nets during the day. To retrieve the catch, the net had to be collected and the fish removed by hand. It was very hard work before machinery was developed to help with this task.

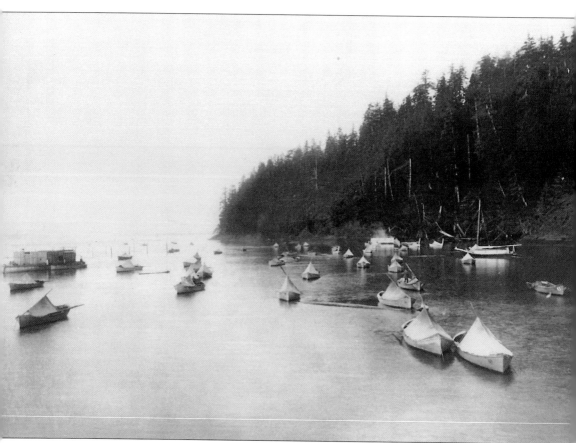

A fleet of gillnet boats rests near Point Ellis. Because the gillnetters worked mostly at night, boats could be seen in the morning with their masts down, floating near the docks. The sail that looked so much like a butterfly when filled with the wind made an excellent roof over the boat at rest. Gillnetters rebelled against fish traps because they thought that the decline in salmon in the river was due to an increase of fish traps in Baker's Bay. For many years, violence persisted as the gillnetters tried to rid the bay of fish traps. The governor of Washington had to call in the militia to protect the fish traps and those who worked them. (Courtesy of MSCUA, University of Washington Libraries.)

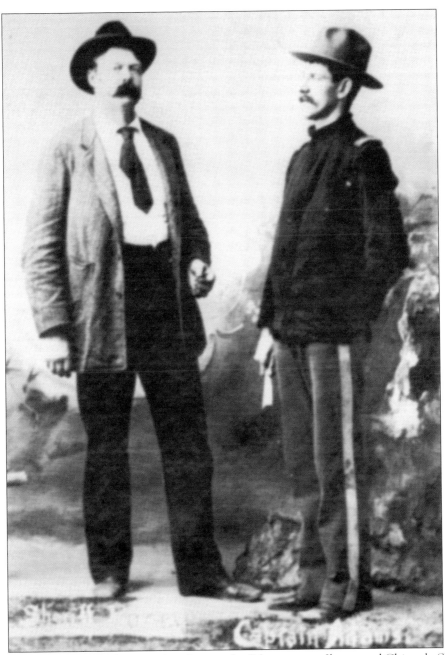

In 1896, 4,000 gillnetters threatened to damage the fish traps near Ilwaco and Chinook. Sheriff Tom Roney (left) knew the strike was too large for him and his men to control yet he still made an effort. According to historical accounts, the sheriff took command of the launch *Rustler* and loaded a six-inch cannon on the bow (it was thought the cannon was from Fort Canby). The sheriff and his men then patrolled along Baker's Bay, guarding fish traps. There were several incidents of gillnetters cutting nets and dynamiting fish traps. Eventually, Sheriff Roney went to Olympia to request assistance. Gov. John H. McGraw ordered out the militia, commanded by Capt. Frank E. Adams (right), which arrived and began to patrol the area. They continued to do so until July 2 of that year, when the fishing season ended.

This photograph shows the tarring process, one of many processes used to protect and darken the nets. Gillnets were put in bluestone tanks each Saturday night, sometimes up to 17 hours. This was done to cut the slime that gathered on knots of the nets. Sometimes tanbark, made from the bark of oak trees, was added to boiling water and the nets could be treated with this solution that would turn them black and keep them from tangling.

This 1897 fisherman's home was typical of those lived in by fishermen and their families. While owners of fish traps and the canneries made quite a lot of money and built large beautiful homes, many fishermen lived in these very small, basic houses.

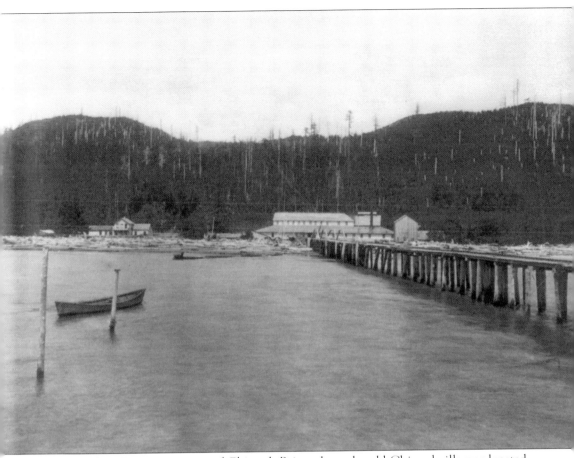

The area of McGowan, just east of Chinook Point where the old Chinookville was located, is where Patrick J. McGowan established his salmon-packing company. McGowan purchased 320 acres of the Stella Maris grant in 1853 for $1,200 and started pickling salmon in salt brine and barrels until the building burned down. In 1864, he built one of the first canneries on the Columbia River. When the canning process was finally perfected, McGowan began to can salmon and solder the lids to seal them. He packed fish under the names Keystone, Cascade, and Blue Ribbon. Eventually, McGowan moved his cannery operation to Ilwaco. Pictured here is the main cannery complex and long dock where boats would tie up. The center also had several storage buildings and a mess house. (Courtesy of MSCUA, University of Washington Libraries.)

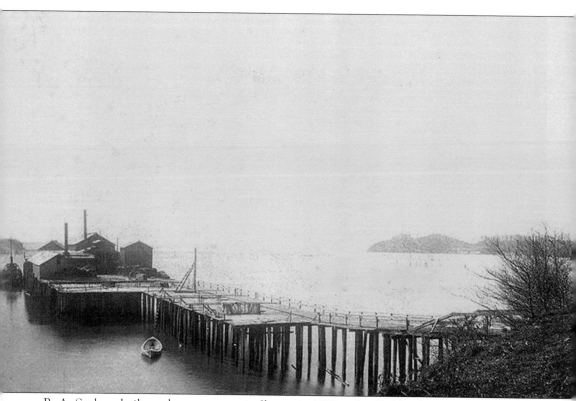

B. A. Seaborg built a salmon cannery in Ilwaco in 1879 and called his business the Aberdeen Packing Company. On August 16, 1898, his cannery caught fire and burned to the ground. This was a period when fish traps were being built in Baker's Bay and the salmon industry was in full swing. Seaborg's cannery, like most in the area, hired Chinese workers to perform the labor. This was the only job in the fisheries that Chinese were allowed to do, as they were not allowed to fish commercially. Many of the workers were able to save the money they made by working in the canneries six days a week and, after a few years, return to China with a hefty amount of savings. Eventually women replaced the Chinese in the canneries.

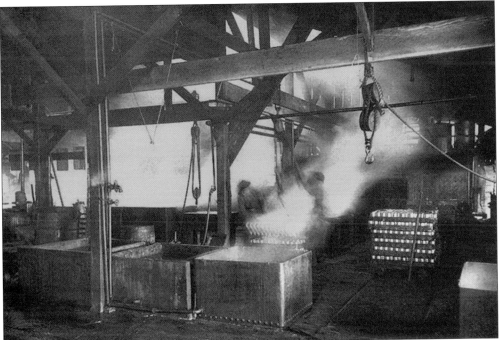

In 1882, Seaborg built a second cannery, the Cape Hancock Packing Company, which provided many jobs in the area. This photograph shows some of Seaborg's workers during the canning process. He also owned a sawmill on the north end of Black Lake, where boards were cut to make boxes to hold the canned fish for shipping.

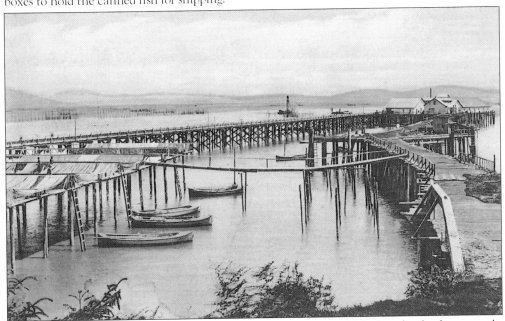

Canneries were usually located at the end of a pier so fishermen could dock and unload more easily. The canneries often owned the boats as well. The fishermen received money for two-thirds of the catch, and the cannery received a third. Boats were rented for the season, and the cost was deducted from the catch. Fishermen worked for the company providing the boats and equipment.

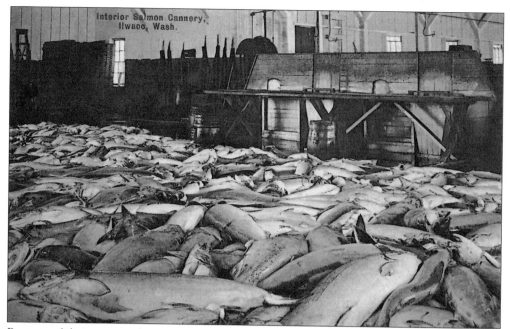

Because of the great number of fish being caught in the early 1800s, a method to preserve the fish became a necessity. After the 1820s, the Hudson Bay Company developed a trade in barreled salt salmon where the fish were cleaned and put into barrels of salt brine. Later, the process changed and the fish were canned in one of the several canneries that operated on the lower Columbia River.

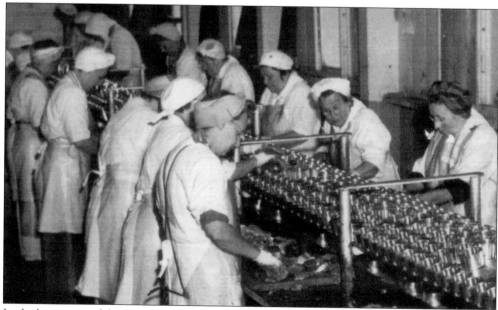

In the beginning of the canneries on the Columbia River, many Chinese were hired, working six days a week, ten hours a day. Most of the workers were single and lived in company housing on China Hill. Eventually the Chinese cannery workers were replaced by women, who also worked long hours in the fish-canning process. (Courtesy of the *Ilwaco Tribune*.)

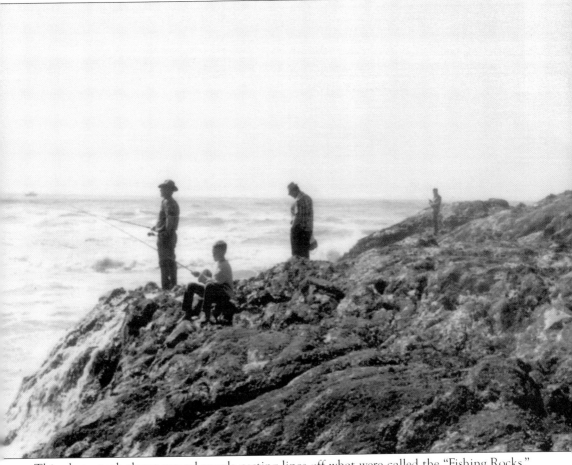

This photograph shows several people casting lines off what were called the "Fishing Rocks," located near Beard's Hollow. Here fishermen could fish for porgies, flounder, and rock cod. One danger of the Fishing Rocks was that if you fished too long you could be stuck on the rocks at high tide. In spite of the danger, this was one of the most popular places to fish. Whole families would make these fishing trips and combine with it a wonderful picnic.

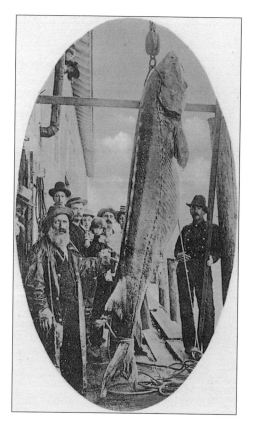

Many people enjoy sturgeon fishing, which are typically quite large. The specimen in this picture weighs about 750 pounds. Photographs often captured these moments to make sure to show the one that didn't get away.

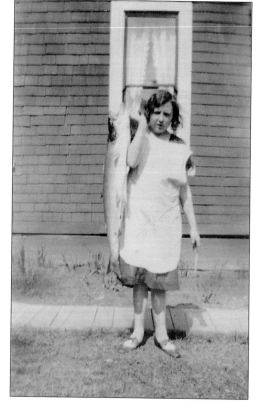

As a young girl, Sylvia Gensman worked at Hotel Seaview, a popular place to stay at the beach. It was here she met her future husband, Bob Gensman. The fish in this photograph was one she helped prepare in the hotel dining room for guests. (Courtesy of Sylvia Gensman.)

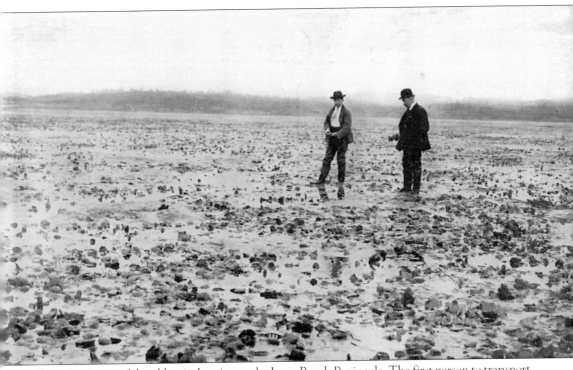

Oystering is one of the oldest industries on the Long Beach Peninsula. The first person to transport Shoalwater Bay oysters to markets in San Francisco was Charles Russell. This photograph shows two businessmen surrounded by hundreds of oysters on the mud flats at low tide. The towns of Oysterville and Nahcotta were supported by the oyster industry and the businesses built up around it. In the beginning, oysters were shipped in the shell, but by around 1900 they were shucked and placed on ice for the long journey. All the work was well worth it because oysters were in high demand in San Francisco, and customers paid a pretty penny for the pleasure of dining on Shoalwater Bay shellfish. For a period of time, the oyster industry almost died out on the bay due to lack of conservation and disease. Eventually, oyster seed was brought to the area from Japan and the industry was revived.

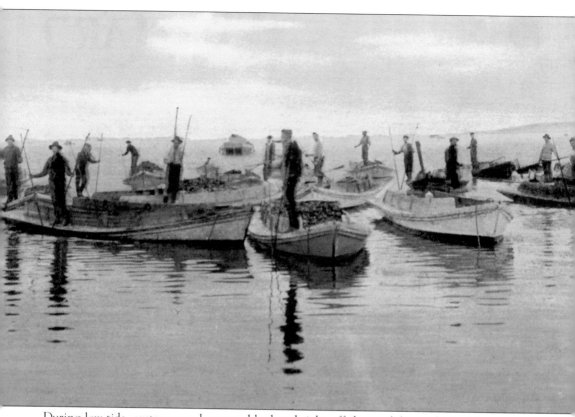

During low tide, oysters were harvested by hand right off the mud, but at high tide, a process called tonging was used. It involves several oystermen standing in a bateaux, a flat-bottom boat using long-handled tongs to harvest oysters off their beds. These tongs were 12 to 16 feet long. At the end of the tongs were two rake-like devices that formed a basket to hold oysters when the handles were pulled apart. When the tide began to go out, the oysters were taken to shore for processing.

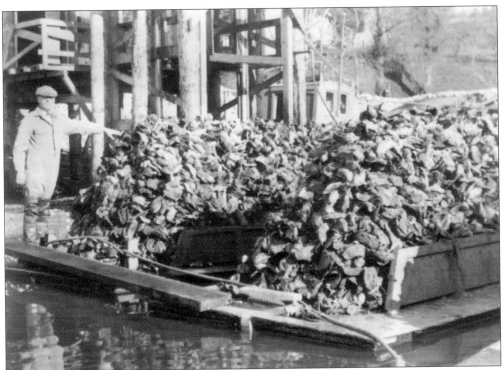

Oysters were transported from oyster beds, stacked on barges, and pulled by boats to the processing areas. These barges were also used to transport oyster shells for use as cultch in different areas of the bay. Cultch is used as a place where tiny oyster larvae, or "spat," can attach themselves. (Courtesy of MSCUA, University of Washington Libraries.)

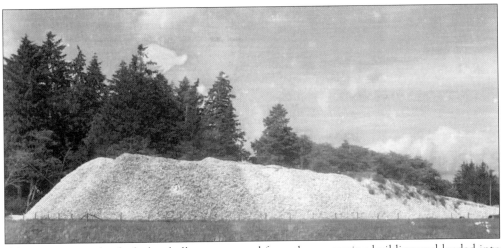

After oysters are shucked, the shells are removed from the processing building and loaded into trucks. The oyster shell deposits create large shell hills. These shells are used for cultch as well as for roads, fertilizer, arts, and novelty goods.

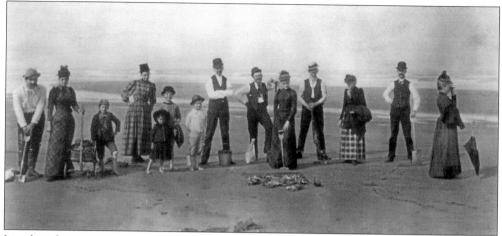

Lined up for a group photo, these friends display their catch of crabs and clams on the beach. With clam digging, fishing, and building sand castles, this group found plenty to do with their day. It is difficult to understand, however, why the gentleman near the center of the photograph has a rifle. Shooting clams is not necessary. (Courtesy of MSCUA, University of Washington Libraries.)

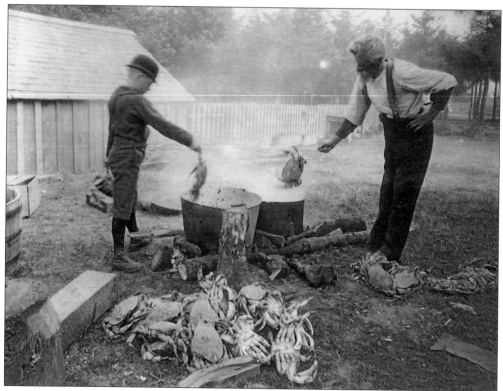

A young boy helps his grandpa boil crabs for the annual picnic. Local residents and tourists harvest Dungeness crabs for sport, but it is also a commercial industry. On the Long Beach Peninsula it is said, "only the lazy go hungry." The Peninsula area is rich in natural resources for those who take the time to catch or gather the bounty. (Courtesy of MSCUA, University of Washington Libraries.)

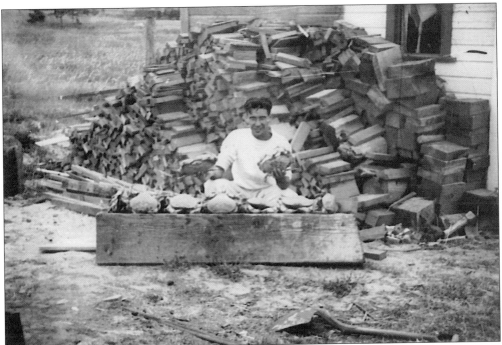

Don Urban displays his catch of Dungeness crab in front of the wood pile at his home in Long Beach. He caught the crab by raking through crab holes near Beard's Hollow and North Head.

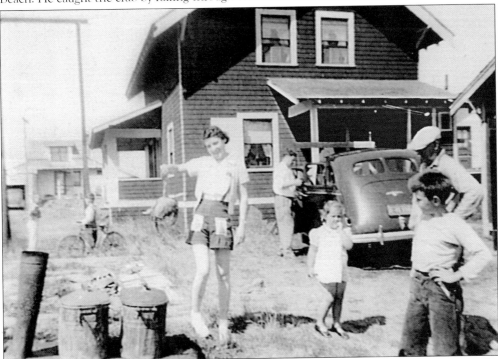

These family members wait patiently for their crab to cook before an afternoon feast. In the bottom left corner, two canners on the fire hold the catch of the day. The girl in the middle holds up a large Dungeness crab for all to see.

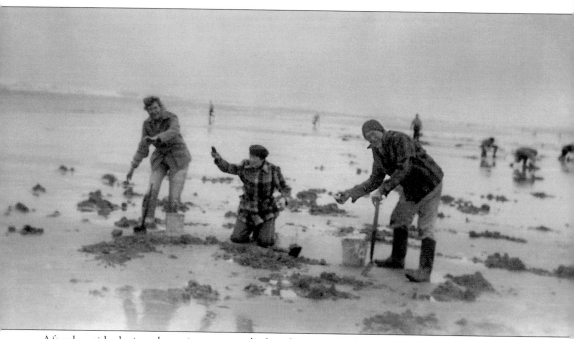

After low tide during clamming season, the beach area near the water was almost always covered with mounds of sand—the remnants of razor clam digging. This photograph shows a triumphant digger. Searching for razor clams was one of the most popular things to do from the time that people began coming to the beach. Even though clamming is now regulated, it is still a popular way to spend time on the Peninsula.

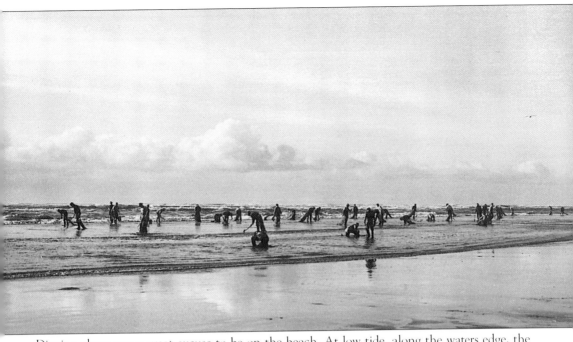

Digging clams was a great excuse to be on the beach. At low tide, along the waters edge, the clam holes indicate where to look. Digging for razor clams along the beach on the Peninsula was a popular family outing, but clamming was also a very popular commercial venture up through 1968. During the Depression, local residents were able to dig for razor clams and sell their clams to buyers for about 6¢ a pound. This photograph shows a typical clam tide. It was not uncommon for hundreds of people to be clamming in an area. If the clams were not sold, they were taken home. Chowder, fritters, or fried clams were all good ways to eat what you caught.

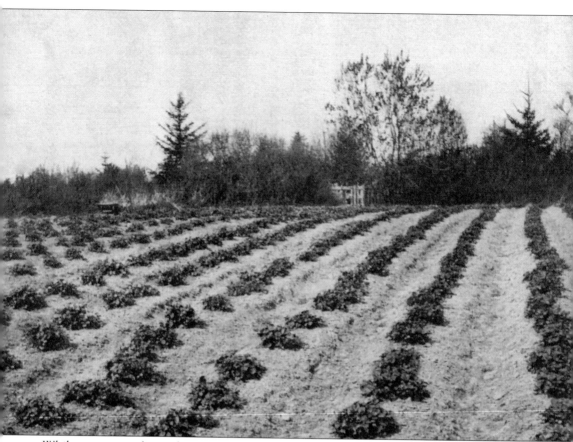

While growing cranberries became one of the most popular agricultural endeavors on the Peninsula, in the early days winter strawberries were grown on the Peninsula in very large quantities. Along with cranberries and blueberries, they were one of the highest producing crops. The berries were planted and would grow to a very large size in the fields, then pickers were hired to gather them when they were ripe. The large juicy strawberries commanded a high price in larger cities. This photograph shows one of the several large berry fields in the area. After the main commercial picking took place, residents and tourists could go into the fields and pick for themselves. They would then pay the grower by the pound for their delicious pickings. Eventually, it became difficult to grow strawberries profitably and the fields were plowed under.

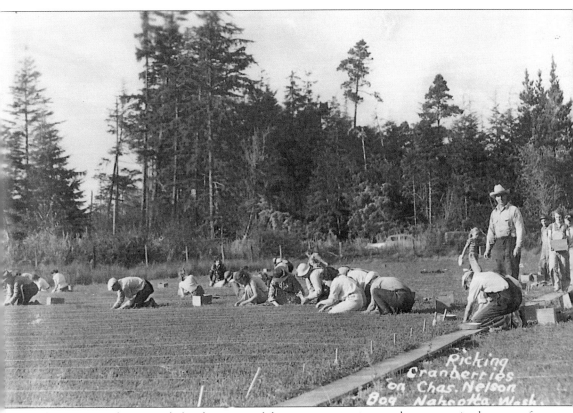

Picking
Cranberries
on Chas. Nelson
Bog Nahcotta. Wash.

The Long Beach Peninsula has been one of the most progressive cranberry areas in the state of Washington. The first cranberry vines were shipped from Cape Cod, Massachusetts, in the late 1890s for planting on the Peninsula by Anthony Chabot. He grew the fruit for several years until the industry almost died out. In 1923, Washington State University sent cranberry specialist D. J. Crowley to help the growers. Those who were serious were able to keep going through the Depression. This photograph shows one of the many cranberry bogs during harvest. In the past, harvesting cranberries involved individuals picking the berries by hand—a method that was very time consuming. String was run down the field to mark off three-foot rows. These picking rows were set up to assist the pickers to completely gather all the cranberries in their area. Eventually hand picking was replaced by scoops, and then finally by machines.

In the late 1800s and early 1900s, timber was a major natural resource in the area. Trees were cut and then logs were transported by train to Ilwaco, where they were loaded onto ships. The Ilwaco Mill and Lumber Company specialized in rough and kiln-dried lumber. Most of their products were made from spruce trees found on the Peninsula.

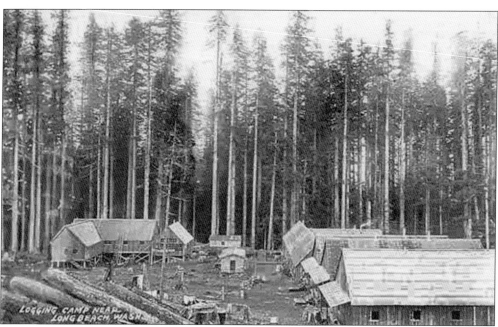

This photograph shows a typical logging camp on the Peninsula. This camp is very much like the one located at "head of the bay" on Willapa Bay. It consisted of an office, quarters for logging crews, and a mess building.

Six

FESTIVALS AND FUN

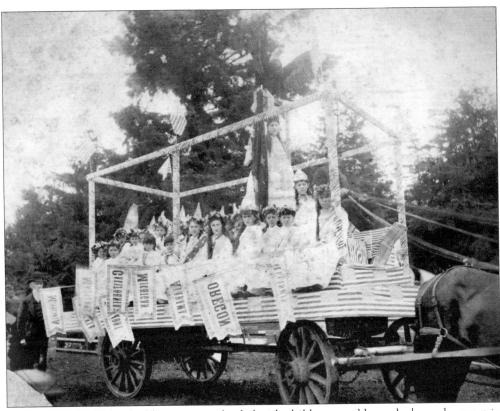

On the Fourth of July, the liberty wagon, loaded with children, would parade down the street in Chinook. Along the way, children would wave flags of the states while Miss Lady Liberty stood at the center. It was always a great honor to be chosen to be Lady Liberty for the event. Parades, contests, and other events made for great fun during holidays on the Peninsula.

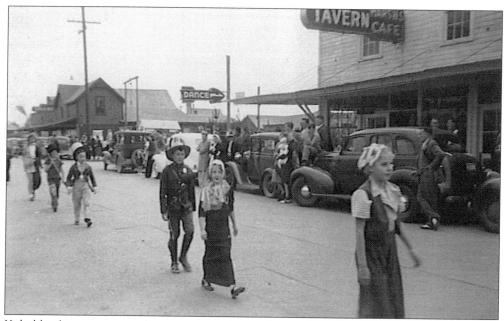

Kids, like those in costume here, were a vital part of the parades held on the Peninsula. A lady, a policeman, and even Uncle Sam march with other children down the main street of Long Beach. Behind the children, proud parents, neighbors, and visitors look on.

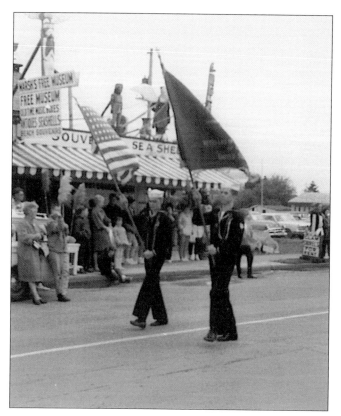

Every Loyalty Day, the Town of Long Beach holds a parade. Here two sailors pass with the Marine Corps flag and the Stars and Stripes. In the background is Marsh's Free Museum, a Long Beach landmark where one could browse the aisles for sea shells, hear the honky-tonk machines play music, and look at a variety of unusual wonders.

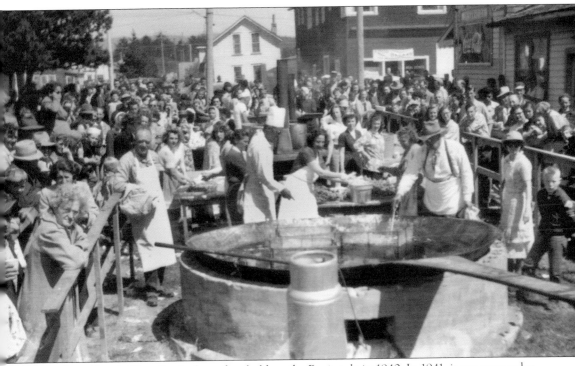

The Long Beach Clam Festival was first held on the Peninsula in 1940. In 1941, it was so popular that more than 20,000 people came to participate and eat the nine-foot clam fritter fried up in the "World's Largest Frying Pan." The gigantic fritter was made with over 200 pounds of clams, 20 dozen eggs, 20 pounds of flour, 20 pounds of cracker meal, 20 pounds of corn meal, and 10 gallons of milk. The frying pan even went on tour around the Pacific Northwest advertising the event. It received much publicity and brought thousands of people to the area. Advertisements claimed that pieces of the fritter would be offered for free and served as all-you-can-eat. A clam festival ball was also held in conjunction with serving the giant fritter. (Courtesy of the *Ilwaco Tribune*.)

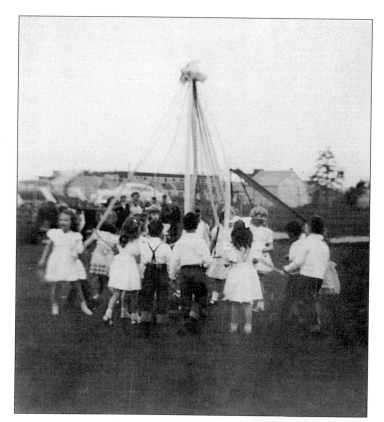

One of the traditions kept by the many Peninsula residents of Scandinavian decent, the maypole was made up of colored ribbons, each held by a person and woven around the pole to create a colorful, braided design.

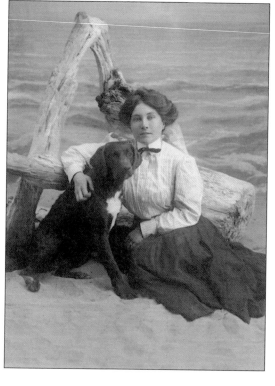

This image was taken at a business called the Postal Shop in Long Beach. It was fashionable to have your picture taken at the beach, have it made as a postcard, and send it to friends and relatives back home. Many postcards would say how much fun the senders were having at the beach and that they "wished you were here."

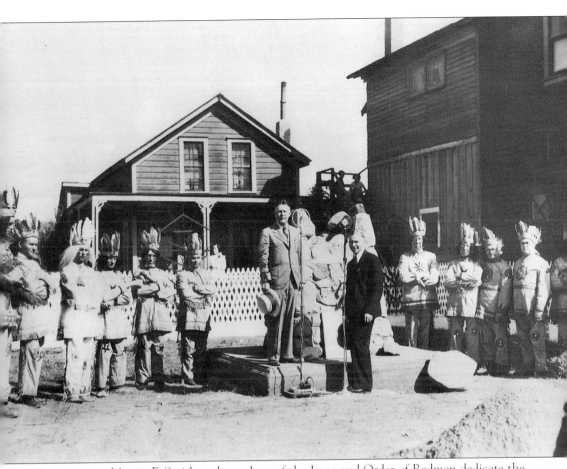

Congressman Martin F. Smith and members of the Improved Order of Redmen dedicate the Lewis and Clark monument near the center of town in Long Beach. This cairn was actually dedicated for the first time on August 20, 1932, by Gov. Roland Hartley and was originally built to commemorate the completion of construction and opening of the Ocean Beach Highway. A few years later, wanting to recognize the arrival of the Lewis and Clark expedition, the old stones were removed and new stones installed, changing the purpose of the monument. It was at that time the ceremony in this photograph took place.

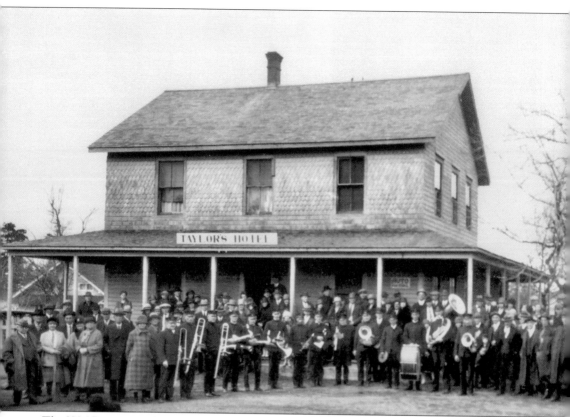

The K-M Boosters, a group that successfully pushed for a highway from inland to the beach, pose in front of the Taylor Hotel in Ocean Park. In 1925, one group of the boosters made a trip from Longview to Long Beach over the newly built Ocean Beach Highway. A group from Ocean Park met the Longview group for lunch in Gray's River where they all joined together and traveled to Long Beach to spend the night. This was quite an event and was reported on extensively in the newspapers of the day.

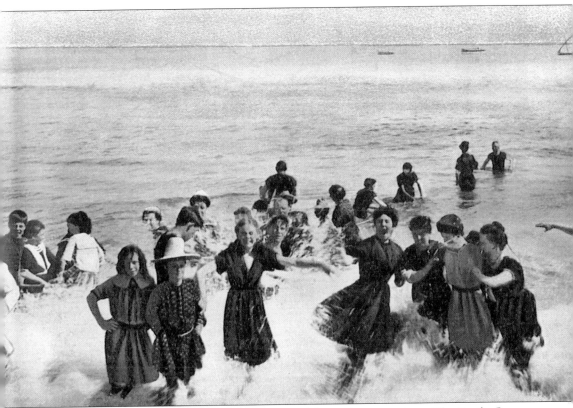

This group of frolicking beach bathers enjoy a typical day at the ocean shore. The Pacific Ocean, with its enticing waves, offers a water playground for tourists and residents alike. Advertisements of the day told of the wonderful bathing beaches and glimmering sand on the Peninsula, and newspapers advertised the best times of the day to bathe in the ocean. But one always needed to be cautious because currents and undertows below the surface could make playing in the waves a dangerous activity during certain times.

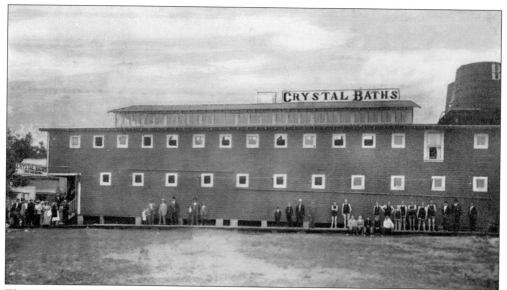

The popular Crystal Bath House, located in downtown Long Beach, is pictured here with a variety of people, including several bathers, posing in front of the building. The Crystal Bath House and Lyniff's Bath House were near each other, and both provided bathing opportunities for tourists and residents alike.

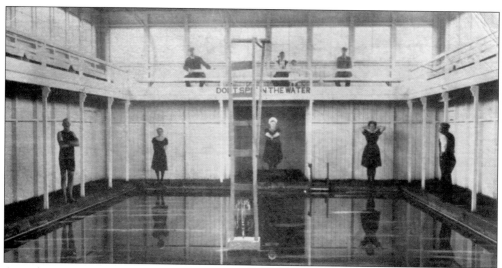

An indoor swimming pool, filled with saltwater pumped in from the ocean was part of the Crystal Bath House. The sign along the bottom of the balcony says, "Don't Spit in the Water."

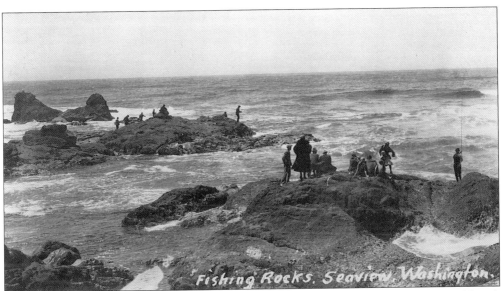

Located in Beard's Hollow, the Fishing Rocks were a popular place to fish. Families would pack a picnic lunch and head for the area to surf bathe, picnic, fish, and play along the sandy beach. Fishermen had to take care because, when the tide came in, they could easily be trapped on the rocks.

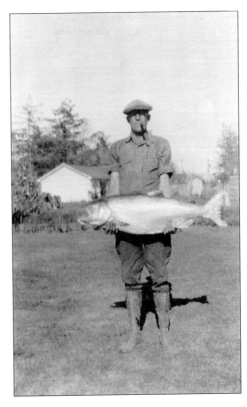

In this photograph, a fisherman displays his huge catch of the day. Salmon come in all sizes. This specimen was typical of fish caught during the early days. (Courtesy of Sylvia Gensman.)

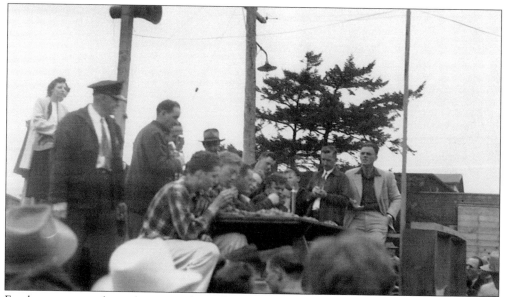

Food contests are always fun to watch. In this photograph, the crowd looks on as contestants eat as fast as they can and the judges keep an eye on the activities.

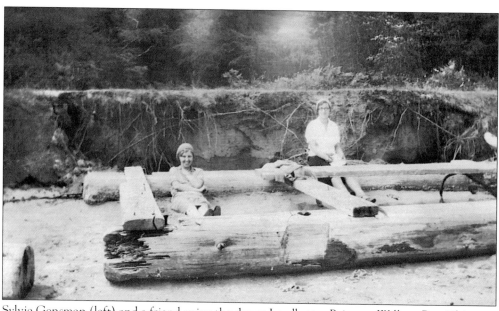

Sylvia Gensman (left) and a friend enjoy the day at Leadbetter Point on Willapa Bay. This area is located on the northeast part of the Peninsula, north of Oysterville. Swimming, boating, sun bathing, watching wildlife, collecting shells, and boating were activities that tourists enjoyed. (Courtesy of Sylvia Gensman.)

The Long Beach Peninsula often advertised itself as the "World's Speedway." With 28 miles of driving beach, it was the perfect place to hold straightaway speed races. The main race was a 50-mile event in which contestants drove their fastest Stephens Special, Stutz Bearcat, or Dodge up the Peninsula for 25 miles, turn around, and race another 25 miles to the finish line. In July 1923, both car and motorcycle races were held at the beach. According to reports, the races were "witnessed by about 8,000 spectators. More would have been there had the ferry service been able to accommodate them." The Peninsula used the car and motorcycle races, along with many other activities such as the Gypsy Motor Tour, Cranberry Fair and Dahlia Exhibition, to entice people to visit the coast.

INITIAL TREE.

The Initial Tree was a popular place for young and old alike to carve their initials. It was also a popular place to have a picture taken or take a date. A person would have to be really brave to climb the tree's heights, but there are many initials in the canopies. This particular tree was reported to have been in the area of the Willows.

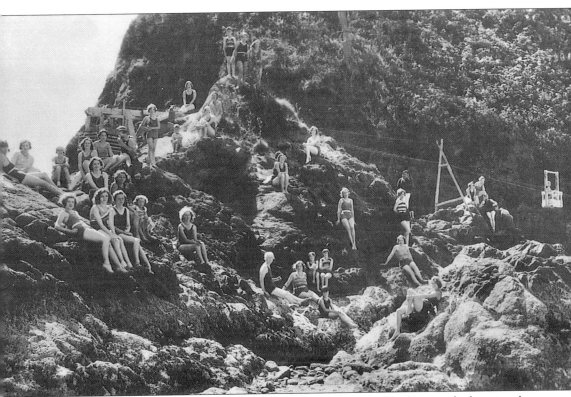

Beard's Hollow was a popular place to go for fishing, picnicking, surf bathing, and relaxation. In 1931, a tram was built by Harry DeMuth from the beach up to O'Donnell Island (Rock), also called Elephant Rock. Before the tram was built, few people could enjoy the site because the rock was surrounded by water even at low tide. Construction of this primitive tram allowed sightseers and fishermen to access the large rock. This photograph shows many bathing beauties posing for the camera with the tram to the right. The first tram was constructed of a breeches buoy attached to the cables, but it was eventually replaced by this wooden basket.

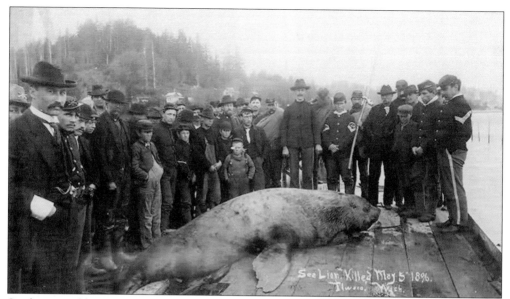

Sea lions would sometimes come ashore or get caught in fishermen's nets. They were known to do quite a bit of damage to nets as well as eat or injure the fish. This especially large specimen was brought onto the dock at Ilwaco. Looking on are townspeople, fishermen, and U.S. Army soldiers from Fort Canby.

Beachcombing can be an active or passive activity. Sylvia Gensman (left) and her friend just happened upon an interesting find as they walked along the beach. A skate was found lying in the sand and the girls spread it out for a photograph. All kinds of interesting creatures and items come floating in with the tide. (Courtesy of Sylvia Gensman.)

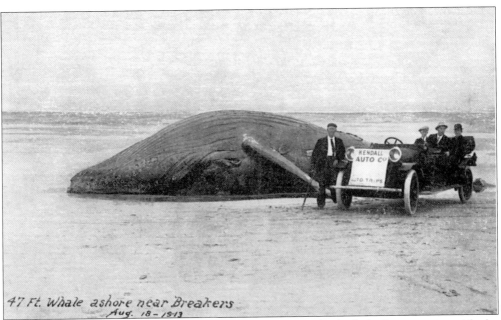

47 Ft. Whale ashore near Breakers
Aug. 18 - 1913

One entrepreneurial gentleman started a "tour" to visit a dead whale that came in with the tide in 1913. The Ilwaco railroad also stopped to give passengers the chance to see whales or shipwrecks on the beach.

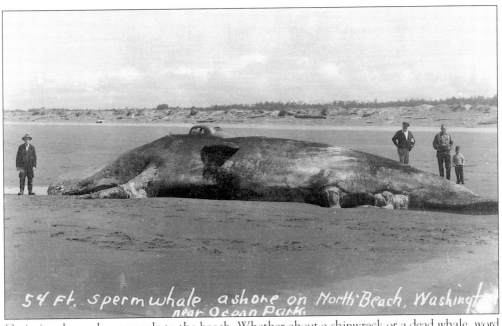

54 Ft. sperm whale ashore on North Beach, Washington near Ocean Park.

Curiosity always draws people to the beach. Whether about a shipwreck or a dead whale, word of mouth notifies everyone to come and take a look. People sometimes traveled miles to see something of interest that washed ashore. It wasn't often that people had the opportunity to see such a large mammal.

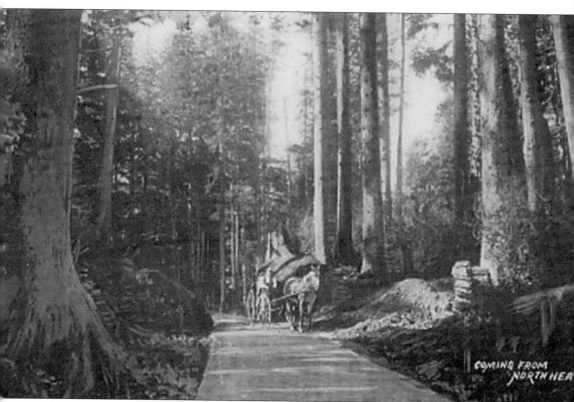

This postcard shows a horse and wagon traveling on the old stage road from North Head Lighthouse. Most dirt roads in the early days were replaced by ones made of planks, which made for a very bumpy and uncomfortable ride. Because of wet weather, plank roads deteriorated. When there was a shipwreck on the beach, much of the wood that was salvaged would go to repair the roads. In areas where wagons had to go over a low spot, a trestle would be built of wood to hold up the plank road and keep it relatively level.

Two festively dressed ladies stop to enjoy the view of Baker's Bay during a walk down the hill from Cape Disappointment Lighthouse. The buildings in view on the right are part of the old U.S. Life-Saving Station and Fort Canby.

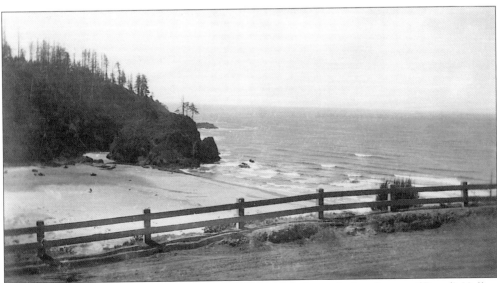

Taken from the Beard's Hollow overlook, this photograph shows the beach area of Beard's Hollow and O'Donnell Rock, or Elephant Rock. The hollow was used for overnight camping, fishing on the Fishing Rocks, picnicking, horseback riding, and other beach-related activities.

Beard's Hollow was named for E. N. Beard, who was captain of the ship *Vandalia*, which sank near McKenzie's Head in January 1853. The body of Captain Beard came aground in this hollow; he was one of four victims of the shipwreck that washed ashore in the area. This photograph shows Beard's Hollow from the area of the Fishing Rocks facing the overlook. The beach at Beard's Hollow was a good place to play. At the base of O'Donnell Rock, beachcombers could look at starfish or sea anemones in the tidal pools or climb on the rock. Other popular places to visit or photograph when going to Beard's Hollow were the Echo Cave, the Harp, and the Needles.

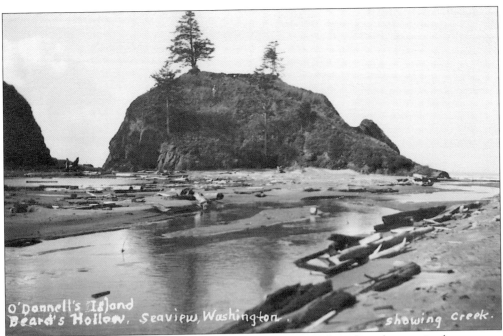

O'Donnell's Island is located at Beard's Hollow; at this time, when the tide came in the area was completely cut off from land. Climbing to the top of this island provided a view of the ocean, the rocks, and the beach. Tidal pools formed around the rocks and acted as homes to various sea creatures.

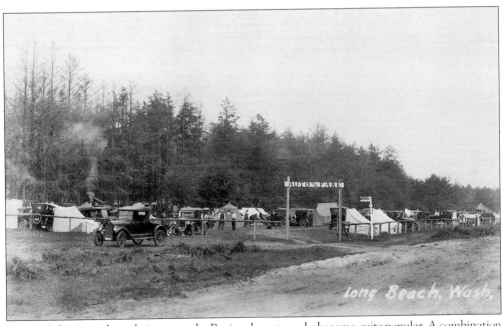

As people began to drive their cars to the Peninsula, auto parks became quite popular. A combination of tents and motor vehicles filled up this crowded auto park in Long Beach. While roads around the Peninsula were quite rustic, this did not seem to stop people from driving to their destination.

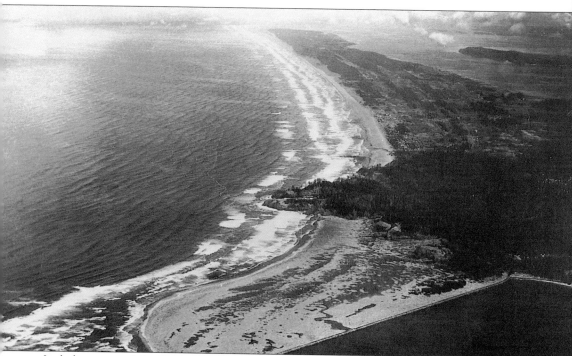

Including most of the Peninsula, this photograph shows a breathtaking view from an airplane flying over the Peninsula. The different shades of the ocean contrast with Willapa Bay and the Columbia River. From this view, the accreted land north of the jetty is visible. This land has built up since jetty construction was completed in 1917, filling in up to 15 feet and added over 1,000 acres between the jetty and North Head. It is now the area of Cape Disappointment State Park.

Joan Carufel stands on the shipwreck of the *Solano*. Visiting, climbing on, and photographing the many shipwrecks on the Peninsula is something enjoyed by many. This image was taken during one of the many times the *Solano* was visible above the sand.

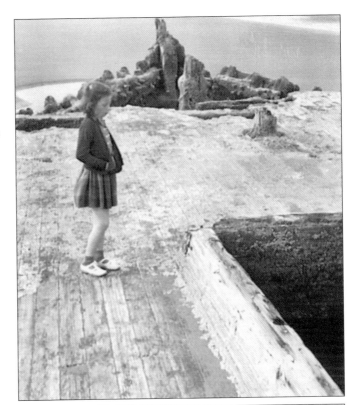

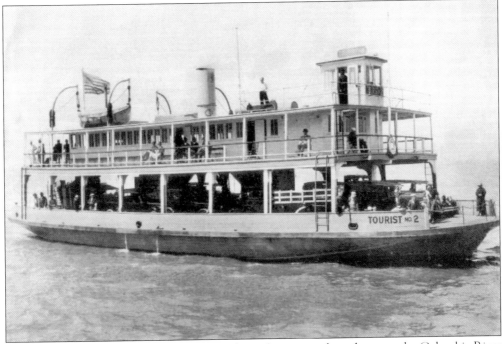

The ferry from Astoria, Oregon, transported people, cars, and goods across the Columbia River to Megler, Washington. This photograph was taken after the road was built to Megler. Prior to that, the ferries and boats met the train at Megler.

This humorous card was used as advertising for the popular restaurant Josephson's in downtown Long Beach. The ad boasts, "Remember . . . If we fry it . . . It's fried in butter." The restaurant was well known for its great seafood and chowder. In the background is the Long Beach Hotel.

WE ATE WITH
THE BIG THE LITTLE
CRAB and SHRIMP
At JOSEPHSON'S
Remember . . "IF WE FRY IT . . . IT'S FRIED IN BUTTER"
Long Beach, Washington

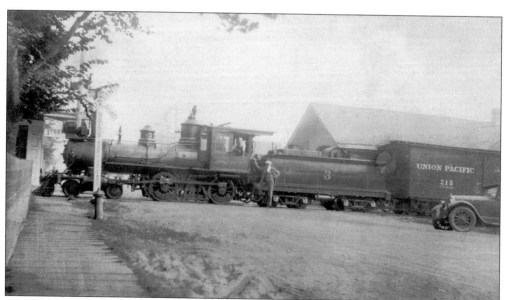

The Ilwaco Railroad ran through the middle of each of the Peninsula communities it served. Here, the train heads north through the town of Seaview. The roof of the Seaview railroad depot can just be seen behind the train. Businesses built up around the depots in all of the communities to serve residents and the people who came to meet the train. (Courtesy of Sylvia Gensman.)

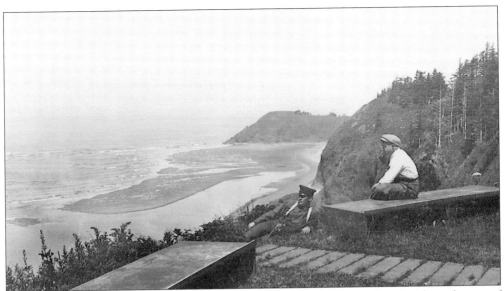

This photograph, taken prior to the construction of the jetty, shows the view from the top of Cape Disappointment looking north. From here, Peacock Spit and MacKenzie's Head are visible. The two men seem to be enjoying the day and the view.

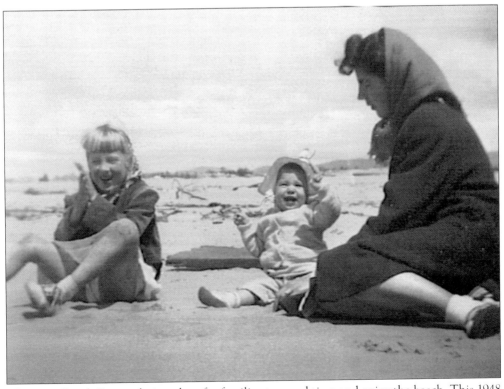

The Long Beach Peninsula is a place for families to spend time and enjoy the beach. This 1948 photograph shows the authors and their mother having a fun time on the sand.

This c. 1932 photograph of the beach on the Long Beach Peninsula shows what it used to look like before grass took over most of the flat, sandy area along the coast. As the seed took hold, grass started to take over and fill in the area from Leadbetter to Beard's Hollow. Where the grasses grew, the sand settled and built up dunes. Where this picture was taken is now covered with beach grass and sand dunes. Much of the upper area of the beach has changed and is no longer flat, sandy beach. Wind, weather, tide, and currents have affected much change over time on this peninsula by the sea.